JEANINE MCLEOD

don't *BLINK*

Capturing Your Child's Story Through Portraits

Editorial Project Management: Karen Rowe, www.karenrowe.com

Cover Design: Kurt Richmond, kurt.richmond@oddballdesignz.com

Inside Layout: Ljiljana Pavkov

Author image by Andi Diamond

Back Cover image of author by Jeff Ebert.
Front cover image © 2019 McLeod Studios, LLC

Printed in the United States

ISBN: 978-1-7339191-0-4 (paperback, black and white)

ISBN: 978-1-7339191-1-1 (ebook)

ISBN: 978-1-7339191-2-8 (paperback, color)

To my beautiful daughter Eryn.

You went from a baby to 12 years-old in the blink of an eye.

Watching you grow into the incredible girl that you are inspires me to be a better mother and person every day.

I love you, baby girl.

"Photography is a love affair with life."
– Burk Uzzle

Table of Contents

don't **BLINK**

Capturing Your Child's Story Through Portraits

Acknowledgements

Writing my first book has been one of the craziest, scariest, and most difficult processes I have ever been through. It never would have happened without the support of my family. While I tried to do most of my writing in the early mornings or late nights when they were sleeping, they still had to listen to me talk about writing my book non-stop for a few months.

To my Mastermind group – Bobbie, Heather, Jeff and Jeremy – your encouragement, support, friendship and faith pushed me to succeed. I love you all dearly and can't imagine running my business without our weekly chats and daily texts. Even when we are old and grey, I will never let you forget that I was the first to publish a book.

To Jeff Skowronek who helped me tie in the science behind my ideas, thank you! There are no words that could accurately express how grateful I am that you took the time to help me. Not only has your insight helped me finish one of the toughest projects I have taken on to date, but you have made me a better photographer because I now pay more attention to the developmental milestones of children.

To my Cloud 9 Studios team – Hannah, Robb, Carla and Carly – your dedication and creativity allow us to provide an incredible product to our clients and bring all of my ideas to life. Thank you for taking on a bit more of the studio responsibilities as I poured hours into writing this book.

To my "Lucky KPI 13" group – we are rock stars! Two words – "Google Spreadsheet". Tracking the word counts and the drive to not let you guys

down is how this all happened! Our time spent together brainstorming ideas, challenging each other to be better versions of ourselves and brand-new friendships mean the world to me. I look forward to celebrating all of your successes, as I know there will be many.

And finally – and most importantly, to my clients who put their trust in me to capture the perfect portraits of their children and create art from their childhood. It is an honor that I treasure deeply and I love that we get to share life's joys together. Your questions such as, "Oooh, Jeanine this session was amazing, now tell me, what are we going to photograph next year" inspired me to write this book.

Introduction

All my life I have loved stories. As a child I would drive my mother crazy, watching and re-watching the same movie over and over again. Specifically, I remember watching Mary Poppins from beginning to end, then rewinding the VCR to watch it all over again. I would imagine that I was the little girl in the movie and since my dad traveled for work, I made up stories in my mind about how I needed a nanny to come play with me. I would act out scenes and sketch in a notepad my very own Mary Poppins. I would tell fanciful stories to my friends (and anyone who would listen) about this nanny who came to play with me, describing in detail the adventures we would go on.

I also remember how my parents and grandparents, aunts and uncles would sit around at family gatherings and tell stories about the homeland (Italy), the war, and life when they were children. While the adults were all sitting around the table drinking and eating, I was lurking in the hallways eavesdropping and listening to their stories. Once my mom realized that I was far more interested in hearing these adult stories than playing with my cousins, she would invite me to sit on her lap and listen.

There were many occasions when my mom would bring out old photo albums and everyone would laugh and share a memory of what the photo was about. I remember one photograph in particular that we loved talking about: my grandmother and grandfather sitting on their front porch, the dress my grandmother was wearing and how she designed and sewed it herself, how handsome my grandfather was as a young man. My grandmother had died before I was born so I never got to know her personally.

13

Through the photographs and stories my aunts and uncles would tell I could almost visualize her in my mind, as if I had met her.

This is how my love affair with both storytelling and photography began. In my mind the two have always been intertwined. Photographs trigger our minds to remember a particular event and our brains fill in the rest of the story. When we go through old photographs, we go through our life history and the more we tell the stories, the more permanently etched in our minds they become. If we tell our stories vividly enough, our children will be able to retain and tell them as well, thus preserving our legacy.

I believe in the power of photography and feel it is vital that we as a society, and especially parents, are passionate about documenting our families and our children. Without photographs, how can we remember all of the stories that make up our lives?

I began my career as a wedding photographer, capturing the most important day in a couple's life: the day they become married. For most brides the day is such a blur; so many brides have told me the photographs and videos I took are the only items they have to help them actually remember the day.

When I began to photograph families and children the same comments were made. The photographs I captured of their babies helped parents remember what they looked like when they were still so small, before they became children who grew into teenagers. Our brain doesn't necessarily remember these details on its own, it needs help!

The more comments like this I heard, the more I grew to understand the real value of my role. Now, as a professional photographer for the past 18 years I see my role as one of "artistic historian" for those I photograph. I help families preserve their memories and legacy through the photographs I take of the meaningful moments of their lives.

When my first child, Eryn, was born, I thought I knew everything I needed to know about capturing her babyhood. This was before the days of cell

phone cameras, but I had my trusty Nikon handy and was ready to shoot anytime Eryn did something cute and memorable. I was diligent about printing my favorite images, either in albums or as framed art for the wall. Fast forward nine years to the birth of Eryn's brother and as I began living the stages of childhood once again, I realized how much I had forgotten. Things I thought I would never forget about Eryn as a toddler were completely gone from my memory. I realized I was so focused on capturing the perfect artistic image of her that I sometimes forgot to capture who she *was*. I didn't photograph the games she loved to play, the books she loved to read or the animals she couldn't separate from. I knew if I had made this mistake as a professional then other parents were making it too. We've been so trained to print and preserve the perfect memories we forget to capture the story of who our children really are.

Late one night, I literally woke up in a panic realizing that I was missing photographs of key moments of my children's lives and started sketching ideas immediately for ways to remedy this. I became obsessed with creative ways to remember who my children were at every stage along the way.

At the same time, the direction for the portraits in my studio took a turn as well. As opposed to just being focused on the perfect portrait, I began talking more with my clients about who they were as a family, who their children were, and what their children obsessed over. Using this information, I began designing sessions that told their unique story.

I have taken my love of storytelling and my obsession with being able to remember as much about my children as possible and poured it into my work and my photography. Over the past 15 years as a photographer specializing in babies and children, I have seen every situation you could possibly imagine and watched children progress through all of their developmental milestones. Through my work, I now preserve these milestones for families; essentially, I capture the story of each child and their family.

I am relentless in my pursuit of perfecting the photography process for a family. I want to make it easy for you as a parent, and make sure you

have zero excuses to not photograph or be photographed. I am always improving on my art so that the photographs I create remain relevant and reflective of current changes in technology, trends, needs and wants.

My hope for this book is to help you not only understand the importance of photographing your children at all stages of childhood, but to walk away with the knowledge that each story we photograph is unique. Your child's story is not like anyone else's. They will sit up when they are ready. They will walk and talk when it is their time. They will throw a temper tantrum when you least expect it. They will learn about things you never thought possible. They will fall in love. They will have their hearts broken. They will become passionate about sports or music or something else. They will do all of these things in their own way and on their own schedule. The photographs we take of this journey through childhood, when strung together, will tell their unique story.

The first part of the book covers the progression of stages, just like a child's life, beginning with newborn and ending with high school graduation. In each chapter, I share a story or two, explain why the stage is unique and important and also provide tips on preparing for the stage in your child's photographic journey. In the next part of the book, we expand the conversation to include the sibling, family, grandparent, and pet portraits, religious milestones, holidays and themed portraits. Finally, in the last part of the book I share with you my findings on different attitudes children have, and how to manage those attitudes when you are photographing them. I invite you to grab a cup of coffee, cozy up in your favorite reading spot and enjoy the stories you are about to read. I want to help you be as prepared as possible for the important task of being your child's personal historian, whether you will be taking the photos, or you choose to collaborate with a professional photographer. In the end, it is my hope the following chapters will inspire you to create your own photographic legacy.

Chapter 1:

Why Pictures?

As parents we are always looking for ways to enhance the quality of experiences for our children. We go to great lengths to ensure each birthday party is beyond our child's dreams, each Christmas is more magical than the one prior and that their childhood is as wonderful as—or even better than—we remember our own.

Throughout all of this we find ourselves acting as the family historian. After all, what are all these experiences if you don't have a way to remember the moments and the years when you are old and gray? Video and photography are the best tools we have to preserve each precious moment in our families as our children grow up, providing us with images to look back on and help us remember the stories that shape our lives.

When I started forming the ideas for this book, immediately one of my clients, Jeff, came to mind. Not only is he a first-time parent, he is also a child psychology professor at the University of Tampa. Jeff and Christina found me while they were pregnant with their daughter, Aria. After several discussions over the phone and a meeting in person at the studio, they decided I was the perfect fit for documenting their baby's first year.

Like many new parents, they were nervous and not quite sure what to expect. Giving birth to a baby human is overwhelming as it is, and the pressure of ensuring their first portraits are perfect can be insane! Even though Jeff is a child psychologist (who happened to help me with this book) everything is different when it is your child. While you may understand the science of why a baby or child acts a certain way, it doesn't

actually make it any easier to be on the other end, helpless to do anything about it. Jeff even admitted to me that it is hard for him to separate out his knowledge from everyday life as a parent.

I began writing this book just after I photographed Aria's First Year Birthday session for Jeff and Christina. I asked Jeff if I could take him out to lunch to pick his brain about how memories are formed and triggered, as well as child development and psychology. It was fascinating chatting with him as not only an expert in the field of child psychology but also a dad.

I place a high value on using photographs to recall our history, and I know that photographs trigger our memories. When I talked with Jeff, he reiterated this fact, reminding me how photographs serve as "primers" for our memories, much like songs or smells. This is why looking at a photo activates the associations we have in our memory. The photograph is the representation of a time in the past, and in order for us to have the memory, we have to make the connection. Once we do, we summon a visual memory of the particular event or time.

Enthralled, I kept Jeff talking. I asked if there were ages in our lives when photographs can trigger memories more than others. Jeff shared that he did not believe there would be a specific age in which photos are better at reminding us of events. Still, it's common for the majority of people to have no memories before the ages of three to three-and-a-half-years-old. According to Jeff, it turns out that most of the memories we think we have before age three are a result of hearing stories or seeing photos connected to the memory – and then making that experience the memory. The memories of our lives increase between three and seven years old but are still not very vivid. The memories we have from age ten to thirty are much more vivid, so if you look at photos from when you were between age ten and thirty, you're likelier to recall more memories.

As I listened to Jeff, I was amazed at how both my beliefs and my experiential findings through my work as a child and family photographer were being supported by these facts about memory. If there was ever

a question of the value I provide as a photographer, it completely vanished in this conversation. While I knew that kids would not necessarily be able to remember their visit to me as a baby, it would certainly bring back memories for the parents and let that child know how much they were loved.

Jeff and I both agreed that photographs play a valuable role when it comes to recording and preserving the history of a family, and notably the development of the children within it. Time truly does fly by, and nothing makes us more present to this fact than having children. While it may seem like every single moment of your child growing up needs to be captured, working with a professional photographer and having portraits done at each milestone is a good way to preserve these major moments in an intentional, dedicated way.

Of course, photographing children is a challenge. This is why you seek out a professional! And this is why I take so much joy in what I do. My work has not only given me the ability to act as historian and contribute to the legacies of families, it has also taught me an infinite amount about working with children. While you may read this and think it's a piece of cake, believe me when I say it's been 15 long years of learning to get to where I am today. Surprisingly, my biggest learning curve hasn't involved the camera, or how to light scenes or evoke moods. No, my biggest learning curve has been working with children!

The coolest part about talking with Jeff was realizing that what I have observed and learned in the past 15 years of photographing babies and children has actual science backing it up! Those sessions where I had been at my wit's end, only to have the idea at the last minute to stick a wand into a three-year-old girl's hand, had been showing me what child psychologists have been observing for years. There are things happening cognitively in children's minds that show when they are ready for imaginative play. There are explanations as to why a two-year-old may not listen to the directions given by myself or a parent, yet a four-year-old can easily take directions. While I thought I'd

been a family historian for people, I was also getting a crash course in child psychology. It is precisely this blend of my deep love of securing a family's history and legacy, plus my fascination with child psychology and storytelling, that have allowed me to grow my photography business—and evolve in my work as an artist—in ways I could never have imagined.

In my conversation with Jeff, I learned that scientific research has found all children's brains go on a clear path from learning things—like a six-month old baby learns "cause and effect"—to letting their imaginations explode at four years old, to other milestones as they become adolescents. While each child may go through these cognitive milestones at a different pace, they all go through them in the same order, each one building upon the next. In other words, the child can't skip a milestone, no matter how advanced a parent thinks their child may be.

As Jeff was talking, I thought of various sessions and scenarios I had observed and shared a few with him. One that leapt to mind immediately was the difference between two princess sessions.

The Tale of Two Princess Sessions

The first princess session in this story involves two-year old Julianna. Her mom, Sarah, had a vision in her mind of a perfect scene inspired by *Tangled*, her favorite movie. We built a setting complete with a boat, floating lights and a castle in the background. Sarah got Julianna dressed and brought her over to the little boat. Julianna of course had to get in the boat herself (hello, Ms. Independent) which was hilarious considering the giant princess dress she was wearing. The entire session was spent essentially tricking this two-year-old into looking in a certain direction and giving us a smile. Julianna was certainly not pretending to be a princess, she was just trying to escape the boat! I kept assuring Sarah that this was

totally normal. Two-year-olds are not really old enough to pretend yet, they are still too busy playing!

In contrast, the second princess session was with a five-year-old girl named Madeleine. Her favorite princess was Princess Sofia and she could tell me everything about the cartoon, all the characters, and her favorite episode. As she was getting dressed, Madeleine continued telling me all about meeting Princess Sofia at Disney World. When I brought her onto the set, she spun around in her dress saying, "Look at me Ms. Jeanine! I look just like Princess Sofia!"

Throughout the entire session, this little girl acted out scenes from the cartoon, spoke to her rabbit as if he was real and was truly in her own little world, pretending to be a princess.

While both sessions turned out beautifully and both mothers were extremely happy with the finished portraits, how we got there was totally different. Julianna, the two-year-old, was simply playing with the props while Madeleine, the five-year-old, used the props to bring herself into her own little princess world. Because of my years of experience working with kids of all ages, I was able to tailor each session to the behaviors of each girl, keeping in mind where they were developmentally and managing the expectations of both myself and their mothers at the same time.

My Big A-Ha: Match Sessions to Milestones

As I left my lunch with Jeff, I reflected on these two sessions and started thinking of so many other sessions I'd had and observations I'd made. It made me smile to think that I had already been giving sound advice and tips to parents on preparing for the sessions, based upon my experience. Even better, everything I'd been observing after my years of working

21

directly with children was backed up by scientific findings in child development. Understanding this not only allows me to match the session to the child in terms of milestones, but even convey to parents what to expect.

In the weeks right after the interview with Jeff, I found myself paying even closer attention to the behaviors of the children I was photographing. I would chuckle as I recognized what was happening with the child as part of their brain development, from getting a one-year-old to throw a ball to me because he wanted to copy what I was doing and play with me, to allowing the two-year-old to choose her own chair to climb on instead of choosing for her. I grew in confidence around my observations. It's funny to think that all my years of photographing children had been giving me the hands-on education I didn't even know I was looking for!

This book and the goldmine of tips within these pages is a culmination of my years of working with children and families to help them preserve their memories with quality photography. I feel so blessed each day to work with children and families, capturing the magic of each unique child's milestones, and knowing I'm helping each family preserve their memories and legacy. Through my lens, I bring the spirit of your child to life, and because of my experience, I can create the best environment for your child to truly be themselves in.

Now, I share my tips with you. When you see your child for who they truly are, and recognize their development, noting each milestone along the way, you are really giving them the most beautiful gift you can give – the story of their childhood captured forever in photographs.

Chapter 2:

The Sweetness: Newborn – 1 Year Old

> "In life there are milestones each rare and so sweet, sharing with loved ones makes them complete."

Baby Grace was only five days old when she came in for her newborn session. Her mom, Carly, was well-prepared for this session because I had photographed her older son Dylan. Sometimes second children don't get the same attention, but Carly had been dreaming about having a girl and she went all out for this session. With Dylan we did a lot of "all-boy" themes such as pirates and baseball. With baby Grace everything was total girl. Carly also brought her wedding dress and a few other items from her wedding to use in stylizing a series of images, which made for a lovely personal touch (and one of my favorites!)

As we were setting up the image it was nice to listen to Carly and her husband reminisce about their wedding and the stories that led them to this day photographing their second child. The story of Grace's newborn portraits will be one that is retold for years to come within their family. Grace will always have the images of herself with her mother's wedding dress to preserve their family's legacy. When Carly saw the images, she cried as the emotions of both her wedding day and her new baby flooded to the surface.

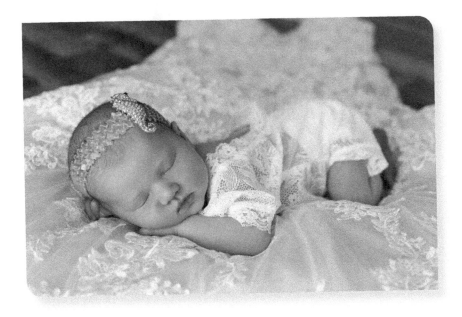

When a baby is born there is so much anticipation, nervousness, excitement and curiosity as to what this new little human will be. The first year of life brings about change like you have never experienced. A baby goes from birth, being completely reliant upon their mother for survival, to walking and starting to talk, all in 12 short months. If you stare at your baby long enough, I swear you can see them grow right before your eyes! Each day and month are worth documenting. Your camera phone will run out of storage in the first few weeks because you feel inclined to capture every movement they make. There are, however, five stages throughout the first year that are quintessential stages and worth documenting with your photographer. Photographs taken at these stages will tell the story of your baby's first year. These are the stages I will discuss in the coming sections.

Throughout this chapter I will also share images from the first year of Aria, Jeff and Christina's baby, so you can see one baby as she grows and changes. It is truly amazing to see a baby go from so small they fit in their parent's hands, to standing and sometimes walking in 12 short months. I will also share a few other favorites, because after all you can never have too many cute babies to look at!

Newborns

The newborn portrait is the first portrait taken in a baby's life. It should be special, timeless and a wonderful experience for the family.

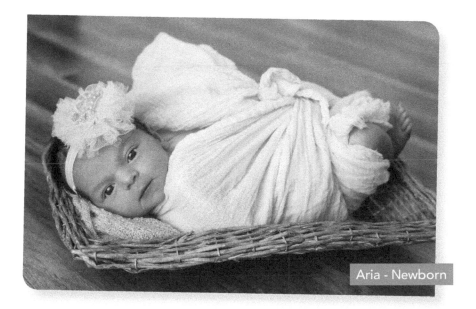

Aria - Newborn

A newborn baby is small, typically under nine pounds and will sleep through most anything. The ideal time to capture the newness of this little person is within the first ten days. During these first two weeks of life a new baby will sleep very soundly and stay curled up tight in the fetal position. This allows us to arrange them in a variety of adorable wraps, baskets and poses without them waking up and crying.

Over the past 10 years the art of the newborn portrait has evolved. When I first opened my studio in 2005, a newborn was typically photographed with the family in a very relational-style portrait. Black and white was very popular and the art was in the simplicity of the shoot. As the years have gone by, and social media and Pinterest have taken over

the world of the new mom, themed and situational newborn photography has become the latest trend. It is not uncommon to see pregnant moms spending months online, planning their ideal newborn photo shoot (and developing crazy unrealistic expectations of what can be accomplished with their own baby within a few hours!) The trap that many moms fall into is giving into the misguided need to purchase outfits and props in order to have their newborn be the next perfect Pinterest post. While fun to plan and dream about, this really gets away from the purpose of the newborn portrait, which is welcoming this new baby to the family and celebrating the life which has been given to this world. What I have found to be the most successful mix is getting that "perfect social media portrait" as well as timeless, simple portraits that will forever be your baby's first set of images. I do this by breaking down a newborn session into three parts.

First, we photograph on a beanbag (often with a heating pad atop) where it is warm and cozy. This is an easy way to get multiple angles, colors, and even a few inserted props or stuffed animals that parents love. We can incorporate colors from the nursery in the blankets, wraps, or hats/headbands and flow through many images with minimal fuss to the baby.

Second, I love to photograph mom, dad and any siblings with the newborn. This is the best way to celebrate the growth and addition to the family. As a mom myself, I know that moms typically don't feel up to their normal selves at this point, so I always recommend they wear very simple dark colors as these are flattering and helpful for concealing any lingering baby weight. If the older sibling(s) is a toddler around two to three, the sibling photographs can often be a challenge and sometimes require a bit of compositing (I share more about working with siblings in Chapter 9). This should not discourage you, however! Remember, for several years that child has been the only baby! Now they have to share the show.

Third, I change things up. If the baby is sleeping well, I move to a basket, bowl or other type of baby container that fits their size and change my lighting setup. The purpose is to give the parents a nice variety in their

newborn gallery of images. With the latest advancements in digital technology and editing I am now able to create newborn composites where one aerial image of the baby is taken in a basket or bean bag poser and then composited into a digital background. These images are very artistic and give me and parents the ability to shorten the length of the session and time that the baby needs to be in the poses by shifting the work into the post-processing of images.

The best advice I can give to moms planning their newborn session is to have everything prepared before the baby arrives. Just like you pack your hospital bag weeks in advance, do the same for what you want to bring to your newborn session. When you come home from the hospital you are tired, and most likely trying to figure out how to navigate this brave new world of parenthood. It is not the proper time for figuring out what to have ready to bring to the studio! Remember that if you have properly chosen your newborn photographer, they will have most everything needed for this session. You just need to bring a few key items that are meaningful to your family and baby. Keep this session simple, do not stress, and enjoy every minute of your new baby.

Pushing Up Session (3–4 months)

The next major milestone in a baby's first year of development is when they can push up on their tummy. For some children, this is around three months, while for others, it may be closer to four or even five. This milestone is lovingly referred to as "tummy time." The toy industry loves this milestone as they sell many play mats that encourage a baby to push up to see the world around them. What is important to keep in mind as a parent, however, is that in this case the milestone is the action, not the age. So if you are looking for baby's first portrait or the first session after a newborn portrait, what you really want to wait for is the baby pushing up onto their tummy.

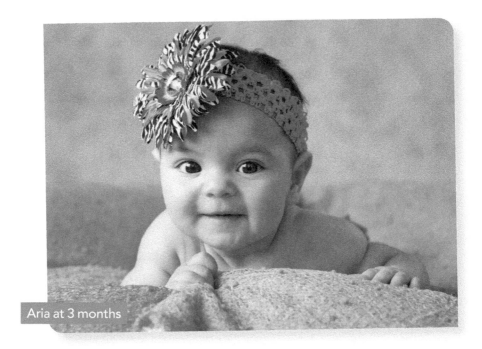

Aria at 3 months

Somewhere between three and four months most babies are very good at "tummy time" and can fully push up on their tummy with their hands from a flat surface. In the studio we can showcase their newfound skill, which they are often very proud of, by having them push up on various blankets and pillows. Many babies can also grab their feet when laying on their backs and this is absolutely adorable! And of course, they do all of this while wearing the cutest smiles and expressions on their faces. It does require practice, however, and I always recommend parents work on that skill prior to coming in the studio.

Some babies will also socially smile at this stage, but it is not a guarantee. Typically, the sound of mom's voice or the touch of mom's hand on their cheek will trigger a happy emotional response and we can capture a few smiley portraits. However, if that doesn't happen at this stage a parent should not worry! Smiling socially isn't consistent until about six months. We can capture other cute faces and expressions during this session.

The pushing up session typically only lasts 30-45 minutes as babies tire out quickly from using these tummy muscles, but the images are worth it!

Oftentimes parents are anxious to come in for their first milestone session if they did not photograph at the newborn stage. As a parent, I totally understand wanting to create adorable images of your baby as soon as possible. When I communicate with any parent before a session, I try to explain exactly what to look for in their baby to achieve the best possible outcome for their pushing up session. If it's scheduled too soon, the typical "three-month" portrait session will end up producing pictures of the baby laying on a beanbag looking up at the camera. They are too old to photograph as a newborn and yet too young to really do anything else but lay there. While this is cute for your daily phone pictures, it does not create the best series of portraits for your baby. I know it can be hard to wait a few weeks, but when you can, believe me, it's worth it!

Baby Stella was four months old when she came in for her first milestone session. By waiting the extra few weeks, she was able to fully push herself up off her tummy and smile while doing so (as opposed to looking strained and upset). Not only was she able to push up, she was able to

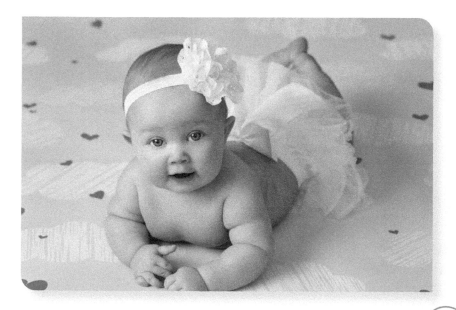

hold it for multiple poses and tolerate a few outfits. Her tummy was strong enough that she didn't get tired out quickly from the exercise. She was also able to lay on her back and hold her feet, another one of my favorite poses at this age. With her ice blue eyes, adorable smile and mastery of her three to four-month milestone skills, her "pushing up" session was killer!

> ✓ Here's a quick checklist to help you know when your baby is ready for their pushing up photo session:
>
> ☐ When placed on their belly they can hold their head up for at least a minute without struggling, turning red or crying!
> ☐ When laying on their back they kick their feet up in the air. If they are grabbing their feet that is a bonus!
> ☐ They can track motion with their eyes.

Sitting Up Session (6-7 months)

Caroline was in our baby milestone plan at the studio and had come in for her newborn and pushing up milestone sessions. Like most parents, Michelle and Jorge were head over heels in love with their baby girl. They had already become believers in portraits and were looking forward to her sitting up session, as was I! Her mom and I planned a few outfits for her session. Then, we set out to capture some images of wee baby Caroline naked, to be done by the windows where beautiful light was pouring in. Caroline was in heaven. As soon as the fresh air hit her belly she began to giggle and when her legs touched the cool floor the biggest grin came across her face.

In order to photograph by our front windows, I need to use giant reflector boards to essentially put the baby in a giant white box. These boards are great for playing Peek-A-Boo! Michelle went behind one board and I had her pop out in whatever direction I wanted Caroline to look. Each time

Caroline would just start laughing with this adorable baby laugh. I knew as we were photographing that we were creating magic. When Michelle and Jorge came back to view their images the following week, they both cried and laughed at the same time. Jorge stared at the giant screen, covering his mouth with his hand, and gasped when the images of Caroline in the back light came up on the screen.

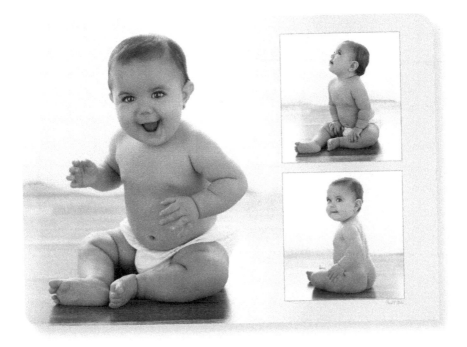

"Jeanine, these are not only the best images of my daughter you have ever taken, but I am going to go out on a limb and say these are the best images of any baby you have ever taken!" Jorge exclaimed.

Hearing this melted my heart and I almost started crying right along with him. Mothers tend to get emotional in the room with me when viewing the portraits of their children, and I am prepared for that, however when dads get emotional, I get a tad weepy too. To look at Jorge and see the incredible amount of love he has for his daughter is truly heart-opening.

He and Michelle cherish the images we created during Caroline's baby plan, especially the images from her six-month session.

As your baby moves past pushing up and heads into their fifth and sixth month, you will notice your baby developing a little personality. They begin to react to your voice and gestures, will often laugh when you tickle them and definitely begin showing their likes and dislikes. During this time their strength and mobility is increasing and they should be sitting up unassisted by six to seven months.

This is the perfect time for the sitting milestone. If you choose to only photograph your baby once during the first year, this is the session I recommend. You can pretty much always get a smile out of a baby this age (unless they are sick or tired) and our minds have been trained to view this as the ideal representation of a baby - one who is sitting and laughing (thank you, Pampers commercials). A six-month session can easily last an hour and most babies will tolerate three or four different outfits which allows the

Aria at 6 months

photographer and parents to design and create a variety of images. This is also when I love photographing naked babies or a baby just in their diaper or diaper cover. Their baby skin is so smooth and perfect and they are so cute you don't need props or anything else to have a stunning image.

Standing Up Session (9-10 months)

By 9-10 months, most babies are standing while holding on to furniture and cruising their little legs around tables and couches or holding onto mom and dad. This is also when separation anxiety can set in and babies don't like being put down from their mother. Often in a standing session I have the baby standing holding on to mom's legs. Doing this reflects a special time: not only is the child now standing, but they are still attached to their parents. They may be growing fast, but they are still a baby. The standing session, much like the pushing up session, can be shorter, around 30-45 minutes. Standing is hard work!

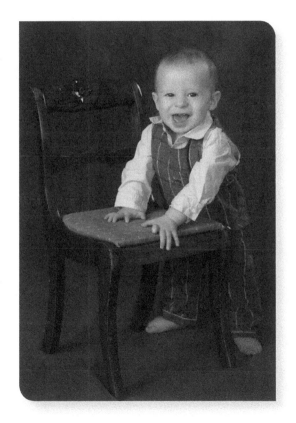

If parents opt out of either a newborn session or being in the newborn portraits, I recommend this stage for the first official family portrait. Since the baby is attached to their parents at this stage, it is easier to go with it

than to fight it! Plus, since they are standing and interacting it can make for fun poses and they are a featured part of the portrait as opposed to a little ball in the hands of the parents. (As an added bonus, most moms have dropped a lot of their baby weight by this point, making for happier mommies when viewing the images.)

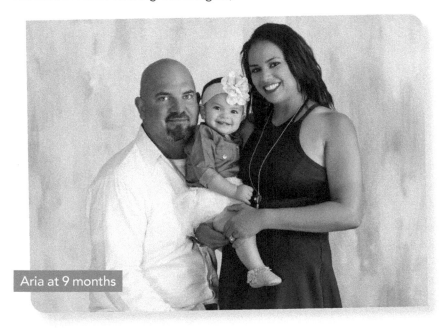

Aria at 9 months

Smashing Their Cake: First Birthday or 1-Year Milestone

Walking, running, playing, babbling and smooshing cake in face ... what's not to love about the first birthday session? I don't have to dig deep into my memory banks to pick out a few heartwarming and funny stories to share with you from a one-year smash cake session. I have had babies do everything from stare at their cake with a "what the heck is this?" face to literally diving their entire face into the cake along with everything in between.

Baby Grayson is the second Fox baby to have their baby milestones photographed in my studio. Having gone through the milestone plan once already with her first son, Jamie was well prepared for each of her sessions with Grayson.

When she told me they were doing a Dr. Seuss theme for Grayson's first birthday, I was all over that idea. Dr. Seuss is a natural theme for children, with wonderfully vibrant and cheerful colors. I have several Dr. Seuss books, but of course Jamie brought *Fox in Socks*—since that is Grayson's last name—along with a few other cutouts she used at his birthday party. Children love to read and look at books, and the more colorful the illustrations the better. Having Grayson sit with these books and flip the pages brought on very natural giggles and smiles. He was even able to stand with the red chair and show off his new skills! When we moved on to the cake smash, Jamie brought with her a sign that her best friend had made for her baby shower, a play on another Dr. Seuss book, *Oh, the Places You'll Go!* with the words changed to speak to Grayson and the journey of being a baby. I love sentimental touches like these to personalize a session.

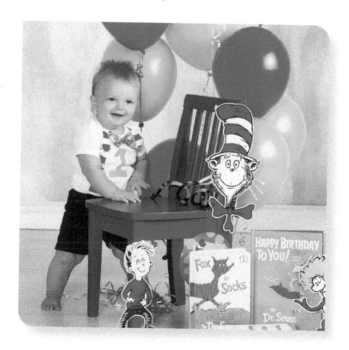

Before sessions I like to make little bets with the parents on whether they think their baby will dive into the cake or pick at it and need a little assistance to make it look good on camera. You might think the parents would have the edge on this bet, but it is usually a surprise for all of us! Really, only about 50% of the time do the parents guess right! Honestly you can never tell what the baby is going to do, even if they loved or hated their cake at a birthday party, their reaction in the studio can be totally different. The only underlying factor I have ever seen to hold true is if a baby hates getting their hands dirty at home (doesn't like touching food, etc.) then they are typically not going to enjoy sticking their hands in cake!

Grayson went to town on his cake. Each bite was bigger than the next and he certainly wasn't shy about getting messy and playing with his cake. Soon enough he was covered in blue icing and began looking like a little Smurf! Grayson's first birthday session is a perfect example of how an idea can come together when perfectly planned between mother and photographer.

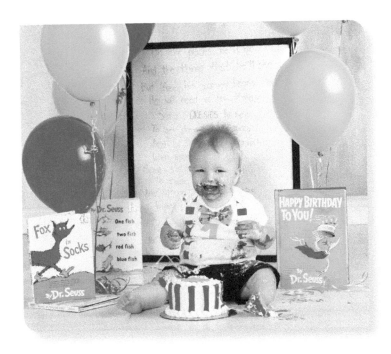

Unlike the physical milestones we've been documenting up until this point, with the first birthday we are really documenting the first of many birthdays this child will have in their life. They can be standing, walking, sitting, it doesn't matter (although it is a much easier session if they can't run away!) As the photographer, I like to plan with families to match smash cake session themes to the birthday party or nursery décor. Doing this is not only fun, it also turns the first birthday portrait into a piece of art to display at home. Regardless of the theme of the birthday, I always recommend photographing at least a few classic, one-year portraits that are timeless and not part of the latest trends. In 50 years when they are showing their children and grandchildren their first birthday portrait it should be something that they are proud of.

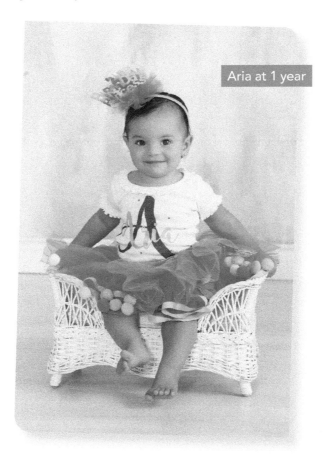

Aria at 1 year

Client testimonial: One-year baby plan

I feel like I have so many favorite images and memories from this entire year. Overall, I would have to say some of my favorite memories and images have to be from our family photo shoot. This is also the shoot where one of my favorite photos of my daughter and I were captured. At the end of a two-hour shoot, 30 minutes of it being in 90 degree heat, my daughter Aria was absolutely done, as any nine-month-old should be. I stripped off her clothes to help cool down some and just gave her a kiss on the cheek. This is when you were able to capture something we do so often but rarely captured on film.

Seeing the album was surreal. In such a short amount of time she has grown so much. It's funny because you never think you would "forget" what it's like to have a newborn or even a three month old, but looking back those memories are so distant. The album serves as such a great memory and reminder of all of the milestones and accomplishments we have hit in the first year. It really is just amazing!

 Tips For Photographing Your Baby In The First Year

It is more important to photograph the milestone then the age. Remember --milestones are given in general stages. Each baby will progress through their milestones at a different rate, especially if they were prematurely born.

Don't rush the development of your baby with unattainable expectations. If your baby is three months old, do not bring in a Pinterest board of all sitting baby images and expect this to happen at your session.

Bring outfits suitable for the age of your baby.

Keep a common theme throughout the first year in at least one outfit for each session. This makes for a fun milestone panel at the

end of the first year as well as allows you to see your baby grow in relation to that theme.

Pay attention to your baby's nap schedule and be sure to schedule their portrait sessions around their happy times!

Do not stress out and please enjoy these sessions. Soak in every moment because I promise you this year goes by way too fast and you will be looking back at the newborn portraits amazed at how you barely remember them when they were that small.

Aside from the newborn session which will most likely take two to three hours, the remaining milestone sessions typically take 45 minutes to one hour. Babies under the age of one do not have long attention spans and tend to need to eat, rest or cuddle when you go much longer than an hour. Keep this in mind when planning your outfits and settings.

Chapter 3:

Two Legit To Quit: Two - Year - Olds

Landon has been coming to our studio since he was three months old and since that time I've had the privilege of watching him grow and change in to a ridiculously cute two-year-old boy. If you are parents of a two-year-old or can look back and say "I survived my two-year-old" you know the secret sauce is keeping them busy – two-year-old toddlers get bored fast! When we do two-year-old birthday sessions I always have four or five tricks up my sleeve with props, food, chairs, you name it, to keep the session moving along and the child happy.

For Landon's toddler birthday portrait session his grandmother totally gets all the credit for the success as she planned out several activities to keep his little hands busy. She brought toy tools, tractors and fake dirt as

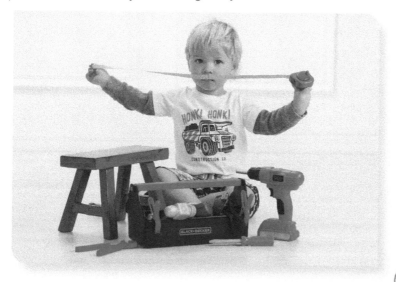

well as the outfits to match. I added a few props to the sets and together we created magic!

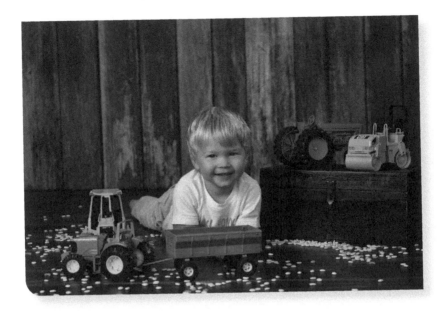

Two-year-olds are interesting little creatures. While they are still very much babies, their ability to walk and talk contributes to an independent personality that lives for testing boundaries. They are testing the boundaries of not only their bodies but their parents as well. My own son was two and a half while I was writing this book. As I would write, he'd stand by the cabinet to the stereo equipment beneath the television, and although he knew not to open the door, all the same he'd stand there staring at me, making a loud noise to make sure I am looking directly at him as he opens the door. For what purpose? Just to see if I will yell "No!" for the thousandth time? Ah. Two.

For any parent who has had a two-year-old, you have likely witnessed your sweet loving baby turn into a screaming mess in a mere matter of seconds, sometimes completely unprovoked. They are still exploring their newfound emotions—and they certainly have not yet learned how to control them. This of course makes for so much fun at a portrait session.

While a challenge, most parents will want a portrait of their two-year-old. Ask any photographer what they view as the toughest age to photograph and most will tell you two to three years old. They are little hellions. Not because they are being bad, but because they have figured out how to "go" and that is all they want to do. Photographing a two-year-old requires patience, trickery, bribery and a little bit of God smiling down upon you to help pull it off.

I am always amused when I photograph a two-year-old that I have been photographing since they were born. In cases like this, the parents are used to smooth sailing sessions. Even a cranky nine-month-old can't go anywhere so we are typically able to peek-a-boo a smile or two out of them. When a two-year-old decides they are done, however, they are *done*. When clients come into the studio for a two-year-old session I always go through my "two-year session disclaimer," which includes the following advice: Parents Beware! Wear sneakers, have a glass of wine, and be prepared for 45 minutes of complete unpredictability. Prepare for the worst and pray for the best.

If the session is a new client, then I'm usually the one praying, "Please God, send a calming force over the studio today. Please help me so this wonderful parent doesn't think that I am a total loser and have no idea how to photograph a toddler. Please God. It is a simple request, help a girl out!" You think I'm joking, but I'm totally serious.

While I am well-prepared with bubbles, squeaky toys, an assistant who can run after the quickest of toddlers, toys to engage in a session, chairs of all shapes and sizes they can climb on and a variety of other items, a little help from the man upstairs is always appreciated.

I have discovered that the first 10 minutes of a two-year-old session is the "grace period." I often tell parents this is when the toddler hasn't quite figured out what's happening yet, so if they have a formal outfit, or some-thing nicer to wear, now is the time to try and get them sitting "properly" in a chair. Once they figure out that they can get up and run like a crazy person and we really can't stop them, the session changes focus to "shock

and awe." How can I shock the child into standing still for two seconds in a state of awe while I click the shutter?

If you are a parent of a toddler, none of this should be surprising to you. I'm sure you have tried taking pictures of your toddler on your cell phone or with your own camera only to end up with a photo of a blurry mess.

I tell you all of this not to scare you, but to help you prepare not only physically but mentally for this session. I often have parents come in with expectations that are completely unrealistic for this age: "Oh, Jeanine, I saw this idea on Pinterest of a little girl who is sitting like a mermaid with her legs off to the side, one hand in the air, the other hand holding a beautiful shell-like statue and she has the magical look of awe at the camera." Yes … and that child is five years old and can easily be directed into that pose. It would take a small miracle and duct tape in order to make your two-year-old do that, and I don't recommend duct-taping your child into position for a session.

The trick is to know what your child enjoys doing and bring lots of it with you. If they are playing on set, then they aren't running. If they are engaged with an activity they enjoy, then they aren't screaming. If they think they are in control, then they aren't trying to test the limits of their parent's patience.

I hope I haven't terrified you! You may be thinking, "Maybe we'll just skip this year. After all, we have so many photographs of Jacob from his first year, we don't really need to go through all this stress to capture his two-year birthday, right?" Erase those thoughts from your mind right now! While your child stops changing as significantly year to year as they age, the differences between one and two, and then two and three, are huge! If you are a parent who loves documenting the growth of their child and want to have a photographic history of who they are at every stage of life, you cannot skip the two-year-old session. At the very least you can then wear a shirt that says, "I survived my two-year-old's portrait session!"

While the two-year-old session is full of energy we can often achieve the most adorable portraits of who this crazy little person is and start

capturing a glimpse of who they will be when they get older. Their face has started maturing and the baby is beginning to fade away. They will have mini-conversations with you and nod or shake their heads when you ask them questions.

One of the keys I have found to photographing this age is getting them off the ground. You will notice in most of my toddler portraits if the child is not occupied with a game, they are sitting off the ground on a trunk, chair or swing. If their feet can't touch the ground, they can't run!

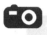 Tips For Photographing Your Two-Year-Old:

Start with the right expectations. Your child is two, not five and thus we should plan the session accordingly.

Plan your session around a child who is well-rested by keeping with their nap schedules. Most two-year-olds are still napping. I may be the world's greatest children's photographer, but if you bring a tired toddler to the studio, all bets are off.

Pack their favorite toys. Pack a bag of tricks and tell me what they are. What is your two-year-old obsessed with? Is it trucks, dolls, tools, blocks, stuffed animals, cars? Whatever they love to sit and play with is what we should be photographing during their session. Bring their favorite toys and leave it to me to create the setting around them.

Keep outfit changes to a minimal. Once we have the child engaged and happy with their session, nothing can ruin it more than changing outfits because then we have to start all over again. That being said, an outfit change can also work to our advantage if a stubborn two-year-old needs a change of scenery. Again, be prepared for anything!

Bring snacks. While bribes do not work yet at this age, food does! Better yet, if we can incorporate food into the session at some point, we can usually achieve greatness!

Keep it short. Two-year-olds are always on the go. You cannot expect them to sit and pose for any length of time. Each outfit or setting will only hold their interest for about 10 minutes. I find these sessions typically last an hour.

Chapter 4:

Three-nagers:
Three-Year-Olds

The best way I can prepare you for the difference between a two-year-old and three-year-old session is to give you an example of what you might overhear me saying during a session:

"Cami, hold that book and look for the dinosaur!"

"Wait, don't jump off the bed yet ..."

"Can you play catch with this snowball?"

"Can you hold this ornament ... OH MY GOODNESS! Look out the window ... can you see that giant bird?"

"Oh wait, come back, don't run in the playroom yet."

"What songs do you like to sing? Can we do the ABC song?"

"Here, would you like a goldfish to eat for a moment? Sit here and we will give you one."

These are all statements that came out of my mouth at Cami's two-year portraits. It was the first time her parents brought her to the studio and like most parents they had high expectations for their portrait session. Cami's mom also openly admitted, multiple times via text, email and

the phone, that she was nervous and anxious because her daughter is a typical two-year-old. Like most moms of two-year-olds I calmed her as best I could and prepared her on what to bring. Her daughter was a handful in her two- year session and as is very common we spent most of the time trying to trick her into a specific spot in the studio to take a picture.

After about an hour or so we succeeded in capturing enough images that even when her dad came back in with mom to view and order the por-traits he was stunned! We worked for it though! This was the session that made me realize I need a shirt that reads: "Photographing Two-Year-Olds Is My Cardio!"

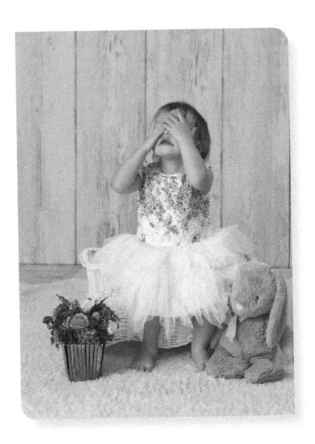

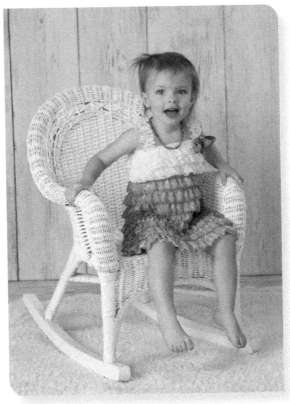

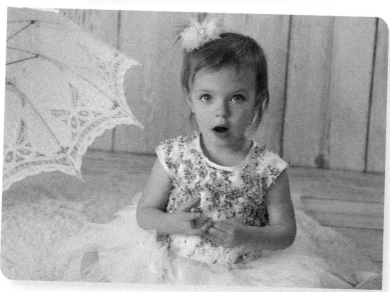

Fast forward a year, and this is what was overheard at Cami's three-year session:

"Cami, can you sit in this chair with your hands folded and look at the camera?"

"Awe that is such a sweet smile!"

"Who is your favorite princess? I have a magic wand, can you wave it and say 'Bippity-Boppity-Boo'?"

"Let's put your bunny over here so he can be your audience while you dance like a ballerina."

"We are going to put you up on this swing, make sure you don't lean back, we don't want you to fall over!"

"Oh my goodness, you look just like a princess!"

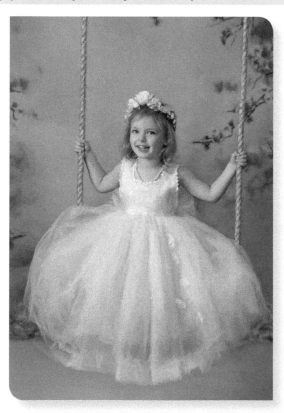

Can you hear a difference in these statements? These were all things I said at Cami's three-year session. Wow! What a change in one year. Instead of firing off ways to trick her into staying in one place long enough to focus the camera, I was able to direct her into a little story of being a dancing ballerina princess who loves her bunny and can light up the room with her smile.

Sometimes I feel if I could just fast forward a year so parents could see it will all be ok, they wouldn't stress if the two-year session is a little less than the ideal they had in their heads. Their child isn't abnormal, their child isn't bad, their child is just a typical toddler going through various phases.

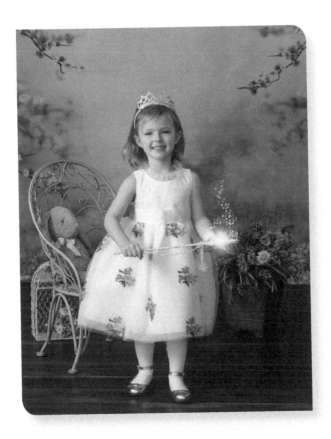

A story from Cami's mom ...

What a difference a year makes between two and three! My daughter's looks and personality changed dramatically. Seeing her every day, I didn't realize the drastic changes. She went from a baby to a little girl almost overnight. At her two-year portrait session she was not cooperative. We couldn't even get her to stay in the studio (literally, she kept running outside)! She cried, said "no", wouldn't sit still, and literally ran off. Thank goodness Jeanine is such a great photographer! I left believing that we probably didn't get very many (if any) good shots, but the opposite was true. When I came back to view my images there were so many beautiful images, I was shocked! They may not have been the traditional sitting-with-her-hands-in- her-lap type of portraits, but they were my daughter's personality. We did get some smiles, but my favorites actually turned out to be the pictures that showed her personality- you know, a little attitude mixed with sass. I loved them!

Fast forward another year, to her third birthday session and what a change! She may not have been completely cooperative (she is, after all, still a toddler), but she was so much easier to reason with. We were able to tell her want we wanted her to do and she would at least try it. It may not have been perfect, but the difference was like night and day. Our session time was actually cut in half! And again, we got beautiful pictures!

What also changed was me. I went into the photo session that first year thinking she would just sit there and take some perfect pictures. Obviously I was so wrong. I spent most of the photo shoot frustrated and apologetic. Because of Cami's two-year session, I had a completely different expectation when she was three. I still went in with high hopes, but no true expectations. I knew we would just run with whatever attitude Cami gave us and I was much more prepared. I had ordered dresses and accessories in advance with a very definite look in mind and sent those pictures to Jeanine ahead of time so that she could have backdrops and props ready to go. That made everything go so much more smoothly the day of the photo shoot. We weren't

stopping to make those decisions during the session, which meant we were able to keep moving and not make my daughter wait and lose interest or get impatient. Everything about her three-year session went so much easier. I'll take those lessons and try to make it even better for her fourth birthday session!

In these three-year portraits of Cami you can see how much she has physically and emotionally changed in one short year. Both stages are only 12 months apart, and any parent may think they can skip this birthday session as not much has changed. Clearly, looking at these two sets of images, you can see that is not the case.

For all the struggles we may have at the two-year session, three is often much easier. While they are still moving bundles of fire and energy, this energy is a bit easier to contain and harness into genuine laughs, smiles and poses. I typically recommend a playful session for three-year-olds, but as you may have noticed in Cami's three-year portrait these sessions can also be more scripted and posed because a three-year-old can take limited directions.

The three-year portrait is important when building a collection of memories of your child and one you should not skip. You will see their faces change; while their smiles are still real and genuine, full of life and sweetness, their baby features are beginning to fade away.

Activities, Collections, and Candy: What's not to love about a three-year portrait?

Remember reading about Landon's two-year session? Well, now at three-years-old he spends many of his days with his grandmother in the garden where she grows vegetables and fruits as well as various types

of flowers. While planting and harvesting with his grandmother, Landon is learning all about food, colors, and of course they are bonding and building memories together.

When they called to schedule his three-year session, his mom asked if we could incorporate Landon's love of gardening with his grandmother into his session. I loved this idea! Earlier in the year I had used a red barn background for my baby duck portraits and knew this would be perfect for Landon's three-year session. I set up the background and styled the rest of the set with crates, a fence, sunflowers and a variety of other garden-style props. When they arrived at the session, Landon's grandmother brought with them boxes of fruits and vegetables they actually grew together. Between what I had and what she brought we designed the perfect set to represent what Landon loved doing at three years old - gardening with grandma!

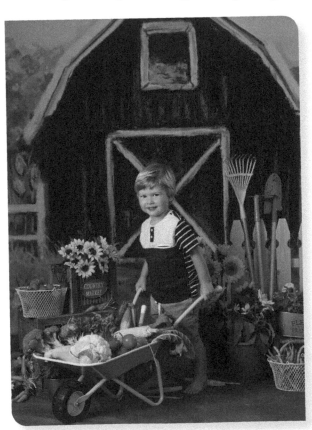

As we walked him through a variety of poses, he was so excited to share with us what he knew about "shucking corn," what watermelon tasted like and how you spit out the seeds, that strawberries and tomatoes are both red and sunflowers are really big and yellow! This session perfectly captured Landon at this stage and will forever provide many stories and memories.

Three-year-olds also love their "collections." If they have found an object they love, it isn't ok to just have one, they must have 100. This is when you will notice kids beginning their collection of hot wheel cars, monster trucks, dinosaurs, figurines, dolls, my little ponies, etc. I love to capture this in a three-year portrait. It is so much of who they are at this age, walking around surrounded by all of their stuff!

Oftentimes for a three-year session I will suggest doing a food-related series of images. While the cakes are typical for a one-year session, and sometimes a two-year, we can do cupcakes, donuts and other sweet treats. Giant

lollipops are a favorite of mine because kids don't often get a chance to walk around with a giant lollipop! When I bring out the big candy on a stick their eyes get as big as their face and they start reaching for it right away! Cracker Barrel is a great local source for these and I tend to stay stocked up on a variety of colors to match whatever outfit a child is wearing.

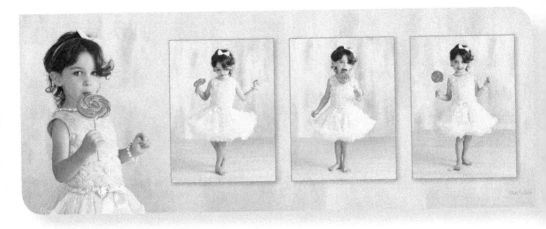

For Avery's three-year session she was all in pink so we matched her with a lollipop and away we went. The background I kept very simple because I wanted to stay focused on her expressions and the candy. This was a great choice —she danced around with that lollipop as if it was her dance partner. When her mother and I went through the selection process we couldn't narrow down to one favorite so instead we designed a collage that showcased all the fun she had.

Every day with your three-year-old is a reminder that they are still babies, but ever so close to becoming that big kid. Soon they will be old enough for pre-kindergarten and many of their baby features will begin to disappear. Their hands become less chubby, their faces begin to thin out and they get so tall! Oftentimes it seems like they need to be asleep in order to see that baby face you know is still there. It really is wonderful to capture this truly fleeting time in a child's life, as they move from baby to toddler so distinctly.

Tips For Photographing Your Three-Year-Old:

Keep outfits changes to three or less. Toddlers at this age will have a favorite outfit and once we hit that favorite, we don't want to stop and change just to hit an outfit count. The child dictates the flow of this session, not the parents!

Make sure they get a good rest in before the session. If they aren't good nappers anymore, schedule for early to mid-morning to ensure the most cooperative of toddlers.

Be sure to let your photographer know ahead of time what they love the most. Imaginative play really begins to kick in at this age. If this can be incorporated into the session you increase your odds of success.

Yummy sweet treats are a great idea for a fun series of images.

Bring their collection of favorite "things" with you (even if it means bringing 100 monster trucks in a box to the studio!)

Keep the session at one hour and no longer. Although you can go a bit longer in a three-year session, you don't want to push your three-year-old to the point of exhaustion.

Chapter 5:

Fun Four-Year-Olds

The first time Francesca came to my studio was for her fourth birthday portrait. Her parents had just moved to the area and they wanted to continue the tradition of photography they began with their photographer back home. They warned me that Francesca was wild and their previous photographer had a challenge keeping her on the set. I told mom not to worry: not only is a four-year-old a lot different than what she may have experienced at a two or three-year portrait, but I am an expert at working with children at these ages to engage them for the camera.

In my mind I prepared a few scenarios to keep this child active and playful. Her mother told me that while she considered Francesca a "girly-girl," she is also very active and can be a little strong-willed. I set up my first series of images with a chair and a flowing tent that hung from the ceiling. The idea was that she could sit in the chair surrounded by the fabric and play peek-a-boo with us. This worked right away. From the moment she sat down she came to life and popped in and out of that tent effortlessly. I think her mother was stunned! The magic quickly wore off, as I suspected it would with an active child, and we moved quickly to the next idea in my bag of tricks: blowing glitter! Children this age love to hold a pile of something and either throw it or blow it off their hands. While glitter can bring out the obsessive-compulsive disorder in many of us and the idea of seeing glitter all over your clothes, hands and floor can make you cringe, if it gets a child to play, have fun and take an amazing portrait, then hey,

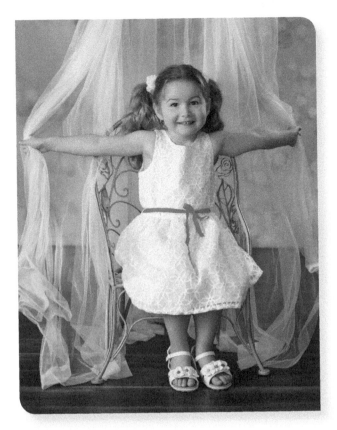

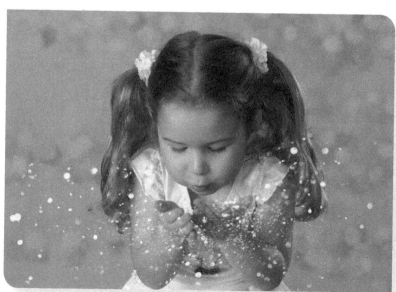

the mess is well worth it! When you combine the real glitter with a little computer magic, the end result is incredible. When Francesca's parents came back to the studio to view their images, they were in shock. They didn't realize what we were going to be able to capture and they were thrilled.

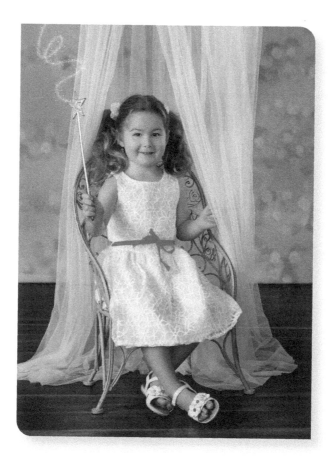

Four-year-old sessions are thrown right into the middle of toddler-hood. You hear about the terrible twos and the trying threes, while four is often perceived as a toddler who "isn't quite five." In their lives right now they may be old enough for a pre-kindergarten program or beginning to play early childhood sports like soccer, gymnastics or dance. Their coordination has vastly improved and they can grasp the meaning of conversations

with adults. There is so much happening at this age that it would be a shame not to capture this birthday portrait. Four-year-olds are wonderful little creatures, their imaginative play is in full force to the point where we can engage them on the set with specific activities.

Tajai has been coming to my studio since he was two weeks old. His mother, Ericka, and I met in a prenatal yoga class and instantly hit it off. Each year for his birthday we always tried to outdo the year before and also bring out his personality, which he was full of! When Tajai turned four, his mom mentioned that he was really loving dinosaurs. Up until this point all of his sessions were done in the studio or in the natural areas around the studio. I threw out the crazy idea of maybe we should head over to a nearby dinosaur park for his session this year. Ericka loved the idea and instantly said yes!

We scheduled a time mid-week to avoid the crowds and went early in the morning before the lighting became too big of an issue. I couldn't bring any lighting with me, so we went armed with my camera, a reflector and an umbrella to help block any unwanted overhead light. Tajai was in

heaven as we walked around the dinosaur park. We acted like we were on a safari, hunting down different prehistoric animals for him to pose with. He was also quite silly that day and allowed his mom and I to direct him with several crazy expressions! Not only did this session provide his family with adorable and unique portraits for his birthday, they will always serve to remind them of how obsessed with dinosaurs he was at four!

With kids of all ages, I always ask the parent what their child's favorite activity, cartoon, character, or sport is. From dinosaurs to princesses, con-struction equipment to glitter, the important point to remember is that this is a portrait representing your child at the age of four. It should play up who and what they are becoming as children. While up until now the baby, two and three-year-old portrait themes have been mostly selected by the parents, this session should be geared towards the interests of the child.

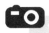

Tips For Photographing Your Four-Year-Old:

Think about an activity or interest that defines your child at this age.

Bring three or four outfits. While it's good to have options, plan on most likely only using two.

This is a fun age to incorporate their "number" into the session.

Consider having the session outdoors. This is a good time for an outdoor session because a four-year-old is old enough to not be distracted by their surroundings and still engage the photographer.

Plan for a one-hour session if you do an indoor session, and up to two hours if outdoor.

Chapter 6:

Fantastic Five-Year-Olds

When little miss Francesca came to my studio for the second time she had just turned five years old and according to her that means she is now an adult. As soon as she told me this, I knew we were going to have a fun session and she was definitely going to have an opinion while posing.

I always make a deal with kids this age that if they let me do my poses first, they can choose a few poses at the end. Children love to show their independence and they usually love coming up with their own silly posing ideas. Francesca was a wild child and full of life during her session. She would flip her hair, fall into her poses and fill the studio with her silly laughter and energy. Her mom just laughed along with me at each click of the shutter: "Yep, that's Francesca!" Those words are exactly what I want to hear. Each session I photograph should capture the child's unique personality and essence. No two sessions are ever the same because no two children are the same. Even twins have different personalities! As a photographer and artist, my job is to create an environment for a child to come to life and be themselves in front of the camera.

The main difference I saw between Francesca in her four-year session and her five-year session was the attitude. While she was a confident four-year-old, we still had to "play" in order to obtain real smiles and expressions. If you remember a few of the portraits I shared, she was blowing glitter, peek-a-booing from behind fabric and waving a wand. At five,

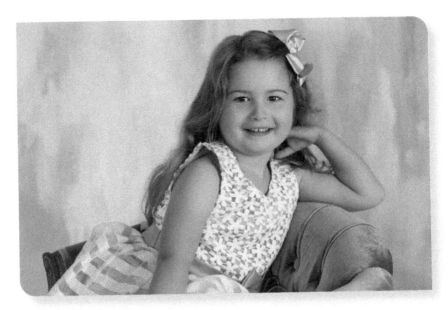

all of those interactions were no longer necessary to engage Francesca in the session. Her personality was able to shine merely from conversing with me and her mother during the session.

I am always asked which age I enjoy photographing the most. That is an interesting question because it's almost like asking what my favorite age of my children is! As a parent I don't have a favorite age; to me, it is always the current age they are at. I love to live in the moment and then look back at the happy memories of our life together as a family. The photographs and portraits we take help us to do this! Really, I love to photograph every age because they are all important memories for the families who trust me to create portrait art for their family.

However, if I had to choose, five years old would be at the top of my list. At this age they are old enough to understand that make-believe play is pretend and therefore can really take it to the next level during a photography session. When a three-year-old waves a wand, it is very frantic and choppy. We are just trying to keep their hands busy. A five-year-old, however, understands we are asking her to pretend to be a fairy or a princess and she should wave her wand as a princess would do.

While many of our sessions in the studio are playful, full of fantasy and magic, the five- year session is one I also recommend photographing in a more traditional style as well. A traditional child portrait is wonderful way to celebrate your child's transition into school age. Of course, this doesn't mean the session has to be stuffy and boring, but at five years old a child can take direction and therefore we can create anything you can dream up!

As an artist, I am always creating and looking for new ways to pursue my art, which is creating portraits of children. Five-year-old children are a wonderful age to photograph when you want to experiment with new ideas and techniques because of their cherub-like faces, as well as their attention span and ability to take direction. A few years ago, I studied with

a photographer who specialized in mixed-media portraits of families and children and fell in love with the look and meaning behind the painting and the process by which it was created. Like learning anything new, it takes practice.

When you look at the old masters like Rembrandt and Sargent, they painted children in very formal settings and poses. This look is timeless and creates a sense of nostalgia for days gone by. In our studio we call this "The Childhood Masterpiece Collection" and it features the child photographed in an old-world setting to give the finished portrait a time-less, classic look. After photographing the image, we then hand-paint it, adding that extra dimension not experienced with a standard portrait. The finished piece is beautifully produced on canvas and framed ready to hang in a prominent location in the family's home.

I first experimented with this on my daughter, Eryn, who was seven at the time, and after seeing the results I knew needed to offer this type of finished art piece to parents of five-year-old children. To continue per-fecting this new skill I invited longtime client, Michelle, to bring her son Wyatt to the studio for a session. She was more than up for the challenge of preparing for this session as she was obsessed with portraits of Wyatt! I showed her the background I wanted to use in the painting and that we needed something "old world" for Wyatt to wear. Her husband actually came up with the concept of painting him like an old-time golfer which I thought was brilliant.

Michelle hunted down the perfect outfit and her husband even had an antique putter we could use in the portrait as a prop. When it came to the day of the session, Wyatt was excited to dress up in what he thought was a silly-looking outfit. As soon as he was fully dressed, his mom and I both looked at him and sighed because he looked so stinking cute! The little old-fashioned hat, the knicker-style pants, the suspenders and bow tie completed a look I don't think his mom and I ever would have come up with had we not been trying to create something new. In the end this

has become one of my favorite portraits of Wyatt. He really got into the posing and had so much fun with my concepts. He crossed his feet, held on to the putter and tilted his head like a pro. While the typical "old master" style portrait doesn't feature a smile on the child, I couldn't help but select a smile of Wyatt for my signature piece from the session. I love smiles on children, especially when they are genuine and from the heart. Wyatt was beaming with happiness that day and is genuinely a happy child. While I was experimenting with a new technique for the studio, I was still creating a portrait of this child and he has a beautiful smile! His mother agreed and the image below is the one I chose to paint for both the studio and his mother.

I would like to point out one other aspect of this painting and that is Wyatt's feet. One of the more popular questions I receive in the studio is "what should my child wear on their feet?" This is an interesting question and truly depends on the scene and the ages of the children. For example, if it is a snowy Christmas scene, then obviously shoes become important as most people don't walk around barefoot in the snow. However, in general, I love baby and children's feet. There is plenty of time to cover those suckers up when we get older and feet are no longer cute. However, with babies and young children their feet are one of the endearing features of their body, don't cover them up! Could we have painted the above image with shoes on Wyatt's feet? Certainly, his mom could have found brown golfing shoes that would have fit the scene. Would it be as sweet and endearing if his little toes weren't crossed and you could see those tiny naked feet? I don't believe so! His toes are part of what makes this a heart-warming image and, in my opinion, finishes of the look of the painting. So here is my advice, when in doubt, go barefoot! Seriously, unless there is snow involved, you can't go wrong.

Just as the six-month sessions capture the essence of a baby, the five-year session captures the essence of childhood. It is before their baby teeth fall out and right before their faces begin to lose the last remnants of their baby cheeks. They start getting taller and thinner and becoming little adults. The five-year portrait captures them one last time at the edge of toddler-hood.

This is what makes a five-year portrait one that a family should not miss out on. This is the end of your child being a baby at home. They will now enter kindergarten and begin the journey of the next thirteen years of their life in school. This portrait will forever bring back the memories of your child as they were before they begin school.

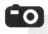 **Tips For Photographing Your Five-Year-Old:**

Select at least one outfit for your session that lends itself to a classic timeless portrait. This is the perfect time for a traditional portrait.

Talk about the session in a fun and positive way. Your child is old enough to understand what is happening so by remaining positive, they will look forward to coming for their session.

Do not, under any circumstance, say the word "cheese" to a five-year-old. This will completely kill the mood of the session and they will give you the fakest smile you can imagine. While this works for two-year-olds because it's new, by the time a child is five, saying "cheese" only produces fake smiles.

Plan on and expect to capture some serious images without a smile. When a five-year-old isn't smiling you can see the true shape of their face and enjoy it before the changes we discussed above set it.

Session length is typically around an hour.

Chapter 7:

School Days:
6 to 9-Year-Olds

When Emma's mom gave me a call to chat about her daughter's sixth birthday she told me that her daughter was full of energy, very girly and couldn't wait to have her portraits made. As it turned out, this was a very accurate description. From the moment Emma walked into my studio, I knew we were going to create magic. She was so

excited about her session that she made my job easy. Emma fully engaged with every idea I had and her little girl happiness shone through to the camera. Can you say, "photographer's dream?" Welcome to the early school age! Eager to please and full of life. This is a fun stage to photograph.

Early school age, when your child is between six and nine, is an interesting timeframe. During this time, children go through first to fourth grades and finish up elementary school. Meanwhile, so much change happens mentally and socially. They learn to read and write, they form friendships, they begin playing real games (the kind that have rules), and they communicate very clearly. At the same time, this is a period of slow and steady physical changes and there is not as much change in their face or height, although the variety in height and size between kids can be huge. While with toddler birthday sessions you can see drastic changes in the face, that isn't the case over the next few years, as the changes are more subtle and typically influenced by hair styles and the number of teeth a child has at any given moment!

These factors—the lack of distinctly noticeable physical changes combined with the increase in busy schedules—often cause a family to slow down

when it comes to having portraits done. But if you think about your own memories of elementary school, aside from a few key moments that stand out, elementary school is quite often a blur for most of us, with memories sparking a sense of feeling rather than bringing to mind the continued string of sequential occurrences that our high school years tend to do.

This is why it's even more important to have a portrait taken in this time-frame. Don't fall into the trap of believing the school photo is enough. Yes, we all get school photos taken of our kids. If you remember the collection you have growing up, these photos aren't always the best representation of *who* you are, they simply reflect what you looked like. And honestly, most school pictures don't always capture that well either. The school photographer has typically less than three seconds to snap that image. Do you really think they can accurately capture the essence of your child in that amount of time? While some families continue with their birthday session traditions, many do not and either come for a few milestones (such as a First Communion, or birth of another sibling) or switch to coming once a year for Christmas.

As one who is passionate about telling the story of childhood, I don't want families to miss out on some of the amazing memories that could be made at these ages. Therefore, each year I keep this age range in mind when developing themed sessions for the studio to ensure that there are options that appeal specifically to the six to nine-year-old. All of our holiday themes work for this age as well for the same reason. I discuss my Themed Sessions more in-depth in Chapter 11.

Since this is early school age, children are used to taking directions from adults other than their parents and this makes for interactive sessions that are full of creativity. I have found that asking questions, getting the child to have a conversation with me and involving the child in the "why" behind a pose will always result in a portrait true to who they are. Kids this age are smart, they can't be tricked, and they definitely feed off the mood of those around them. Parents should pay special attention to this and keep the mood leading up to the session happy and upbeat, zero stress.

Involve their best friend or two. As kids this age start to become aware of the value of friendships, life long bonds can begin to form. Foster this by inviting a friend or two to a session. Just like a sibling portrait, they will bring out a different side to your child, and each other, than you normally see in front of the camera. Not only will this become a unique capture of their personality at this age, but also who was most important to them. Imagine if they remain friends into high school, or even adulthood, how amazing it will be for them to have these images from when they were young!

Design the session around their growing interests. Does your child have a favorite book or activity? With their ever-growing curiosity combined with independent thinking, get them involved in planning their session, they will definitely have an opinion and love being able to express it!

Clothing should be simple but true to who they are. As with most sessions I recommend your child is the star, not the clothing. Keep the patterns to a minimum while still letting the colors and style reflect the personality of your child.

Don't schedule the session for after a long school day. School is draining and long on kids this age. I find that if a parent tries to cram a portrait session in after a day at school, the kids look and act tired. Try to schedule it on a school holiday, early morning before school or a weekend.

Keep it short and sweet: Half-hour for the session is enough. While kids this age are super attentive, their attention span is also very short. They may love all your ideas one minute and then get very antsy the next minute. There is no need for an hour session at this stage. They can take direction quickly and besides you have a million other things you need to be doing. In 30 minutes you can knock out amazing memories of these ages!

Chapter 8:

All Hell Breaks Loose: Pre-Teens & Teenagers

D on't ask me how, but life really does start to speed up once junior high and high school start. Your household might become a blur of activities, with hockey bags, ballet tights, and other gear strewn throughout. Suddenly, you're the chauffeur, taking the kids here, there, and everywhere. It can be really hard to make time for a portrait, not to mention dealing with the ups and downs of any pre-teen and teen mood. I know it might seem unnecessary to bother having a portrait done in this timeframe, but believe me, it's worth it. This period of pre-teen (10-12 years) to teenager reflects changes that are truly monumental in your child's development, and warrant capturing through photography. This is also a challenging time for a child's self-confidence as their bodies continue to change. Having photographs that reflect who they are not only helps build their confidence but also remind them that they are loved.

Pre-Teens (10-12 Years Old)

To a child there is nothing bigger than becoming "double digits." Going from nine to 10 is a huge deal as it not only marks the end of their first decade of life but also the beginning of their pre-teen years. Grab a box of tissues, a bottle of wine and a sense of humor because the next few years are going to be quite the ride.

While many parents are religious about photographing their babies and toddlers at least once or twice a year, as they progress deeper into the school age this often drifts away to just Christmas or a special event. However, once the "big 1-0" birthday approaches I find many clients calling to bring their baby in for a birthday celebration portrait. While we aren't smashing a cake like their first birthday, this session is nine years in the making and has just as much significance and fun associated with it.

"We found Jeanine and Cloud 9 Studios when our first son was born 10 years ago. She photographed him throughout his first year and we still look back at these images today and smile at how small he once was. Wow, the time goes by so fast!

As our family grew, so did our portrait collection with Cloud 9. Now all three of our children have been through the baby plan and we come every year for Santa portraits. This year, however, was a big milestone. Our oldest son turned 10 and we knew we had to go big! I scheduled a custom portrait session for him with Jeanine that combined some formal images as well as the fun activities and hobbies he enjoys (karate and Pokemon). My mom and I laughed and cried during the session as we watched him be silly, be serious and basically just be JB. There is nothing in my life more important than my family and having these portraits to document the years and the memories of my children mean more to me than anything."
– Lindsay Williams

When talking with parents about the tenth birthday portrait session I always ask them a few important questions:

1. What is your child obsessed with right now?
2. What is most important to you about having this portrait made?
3. Have you thought about where this milestone portrait will fit in your home?

Once I know the answers to these questions we can make a game plan for the session. By incorporating what they love along with what the parents want we can keep everyone engaged in the session and create a finished series of images that the child will be proud of and the parents will treasure for a lifetime. One decade down, nine more to go!

Between the ages of 10 and 13 your child turns into a teenager. They become very active middle schoolers and go through many changes, the most important of which is entering puberty. Their bodies and emotions go through all the changes we have such "fond" memories of from our youth. The only time I typically see children this age in the studio is if they have younger siblings and come in for a holiday or a family portrait. For our holiday scenes in the fall I am very aware that children this age teeter on the edge of wanting to still be a kid but feeling the tug of being older. While we still view them as our babies, the world and their friends are telling them they are old.

I find many of my clients fade away and don't come in at all when their children are around this age. They may do the tenth birthday portrait because it is a huge milestone but then it is like some magic dust is sprinkled over their child and they no longer feel the need to document who they are each year. This magic dust is called pre-teen moodiness. The mood swings of your puberty-affected child mixed with the insane schedule that comes with an active pre-teen in middle school, sports, music, Scouts, and so on, makes it very difficult to think about scheduling a portrait session.

I also know that kids this age don't think it is cool to be photographed anymore. I began to see this with Eryn, my own daughter, who dreaded coming to the studio, something she'd always loved up until then. When I saw the eyerolls and the bored look on her face, I knew this wasn't just a line clients were feeding me about their child not wanting to come, it was for real. This is when I knew I needed to create a series of sessions that older children would love and enjoy and would represent who they are.

I sat down and thought: what are children this age truly into? What gets them excited and what do they love? While this may vary from kid to kid,

I realized from conversations with my daughter and her friends they all loved Harry Potter. This is what inspired me to begin designing themed experience sessions where kids can come dress up and participate in a session that makes them feel like they were part of their favorite movie. As I mentioned earlier, I will discuss my Themed Portraits with more detail in Chapter 12.

Although I have added more and more themes to my collection, over the past three years our Wizarding School Portrait sessions have been a top seller for not only kids between 10-12 but also that seven to nine-year-old age range. Heck, I have even had a few parents get in on the session and adults asking if they could do it without their children! This is when I realized that like Christmas, Harry Potter has become a nostalgic character for parents. Most of my clients are in their 30s-40s and grew up reading the Harry Potter series as teenagers. With the opening of The Wizarding World of Harry Potter at Universal Studios, parents have introduced this world to their children when they reach the right age through an amusement park, the books and movies. Now their favorite series of books can be shared with their children and this alone makes these sessions a success for any fan.

This experience taught me three things:
1. Choose themes that kids will love and parents can relate to.
2. Be sure the sets are interactive and playful so kids have something to do.
3. Decorate and theme everything for the session (confirmations, session snacks, decor, etc.).

Creating the themed sessions was a true stroke of genius on my part. When your child comes for an experience and gets to act, play and have fun, they now have more than just a portrait, they have a memory and story to tell. They are excited about being the star for an hour and proud of the art that will hang in their home that is made from an image of themselves!

Teenagers (13–16 years old)

As children go through puberty, become more involved in sports, activities and the time commitment to school increases, the desire of both parents and children to come for a photography session—or for parents to even pick up the camera themselves—wanes. As well, many times, the activities they are involved in capture photographs that are enough to satisfy the desire of a parent to have that year documented for their child.

The most common reasons for portraits at these ages are religious or cultural. As children go through puberty they also go through "rites of passage" and these occasions usually lend themselves to a portrait. In upcoming chapters I discuss religious milestones in greater detail, but there are also cultural milestones such as Quinceañeras and Sweet Sixteens. In parts of the country Debutante Balls are still quite popular as well.

Aside from these "coming of age" sessions, most teenagers are only photographed as part of a family group for an annual family portrait or holiday. This is why the Senior Portrait, normally taken the summer before your child's junior year, is such an important one. Honestly, it is most likely the first time in

close to 10 years the child will have been photographed where the session is all about them and their interests. Nothing to do with family, nothing to do with religion, just the child and who they are at this age.

As a parent, going through these ages with your children can be rather tough as well. Children of this age are searching for their independence, their own voice and of course dealing with changing hormones, and as they do so, they often fight and argue with their parents. The once sweet child becomes a moody teenager and the constant arguing about what to wear to school and out to the mall with friends spills over into deciding to what to wear for a portrait.

Don't be daunted, however. Even though they are hormonal and angry, sleeping all the time or just plain busy, each year is unique in your child's development. The teen years are no exception. Just watch how they transform—in their interests, in how they respond to the world, in how their dreams start to shift. When you look back and see the bright-eyed face of your 13-year-old and contrast it with the more studious expression they may have in their senior portrait, you'll be glad you made an effort to capture each year of their development.

As a mother myself, I know this is a tough age to schedule time to photograph regardless of our best intentions. If a portrait was made at 10, and scheduling portraits isn't happening every year anymore, then I encourage you to at least make sure you celebrate how amazing your teen is at some point between 13 and 16. This can be a portrait celebrating their "coming of age" as mentioned above, a religious ceremony, their first car, or their achievements in their extra-curricular activities like sports or any other interest that is important to them. Remember, your child is going through a lot of changes at this age and are often not happy with their body and their looks. A properly made portrait or series of images is an experience that helps build up their confidence and their feeling of love and acceptance in the family. Finally, let this be a bonding time for you and your teens and refrain from putting stress on them or arguing about trivial things relating to the session.

The High School Senior Portrait

If you just had a baby or your child is very young you might be looking at this chapter thinking you can just skim past this because it will be forever until your baby is a senior in high school. Let me tell you my friend, it comes at you quicker than you can possibly imagine. Today your precious baby is a year old and tomorrow they are waving goodbye as they leave for college. I hope this chapter helps you hold onto each moment with your child at whatever age they are. Time goes so fast.

Exactly what are these "senior portraits" you keep hearing about? Often when I refer to the senior portrait, people think I am talking about portraits of grandparents and other elderly people. Although I do love capturing memories of our grandparents and that generation, by "senior portraits" I mean the portraits I create of teenagers as they are about to graduate high school. Ironically, these are typically done over the summer before the teen's senior year of high school because most yearbooks have their print deadlines early in the school year.

Chances are your own senior portraits were taken in your high school gym, or if you did go to a studio, they weren't that big of a deal; perhaps your parents ordered them just like other school pictures. You had to wear a formal suit or tuxedo as a boy and a little black cape as a girl and maybe one or two other outfits on a series of backgrounds you could choose from. It was very processed and very repeatable, therefore nothing about these portraits actually showcased who you were as a senior in high school, they simply documented your final year of school in a bigger way than your other school portraits.

Senior portraits are about celebrating the final life stage of childhood. After this last year of high school your child is now an adult; most teens are off to college, the military, taking on their first job, and so on. Senior year is full of its own coming of age milestones and is worth celebrating

in many ways. I'm sure you and your senior will take hundreds of photographs of homecoming, prom, parties, trips, college acceptance letters, and other highlights of this time in their lives. This is their last year of high school, likely their last year with friends they grew up with and possibly their last year at home. Even if they live at home while in college, or at 32 in your basement playing video games (let's hope not), it will never be quite the same as when they were 17 and still your "child." This is it. The last true stage of childhood before they are welcomed into adulthood.

I often tell parents the senior portrait of their child is the last true photographic celebration of who they are as an individual until they get married! It sure puts things into perspective timewise for you, doesn't it?

Senior photography has come quite far over the past few years. We have a lot to thank for that; technology, trends in the media, the internet, and Pinterest, to name a few contributors to this evolution. Within the last 20 years, and even the last 10, the senior portrait has transformed from an assembly line to a customized experience like none other if you go to the right photographer. I am constantly amazed at the art I see being created in this market. If your child is an athlete, for instance, what many photographers are creating is nothing short of movie magic, composites of athletes that would make Tom Brady wish he could go back to high school and have his football portrait created again. Of course, while athletes have always been celebrated in high school, now we see all interests of kids being praised and forever preserved in their senior portraits. Music, theater, art, gaming, academics, fashion, it doesn't matter what your senior is most passionate about, we as photographers can take that passion and create a unique piece of art to commemorate this milestone.

Unlike when your child was a baby and you simply took them to the photographer and squeaked a frog at them to make them smile, they now have an opinion, and lots of them. How did this happen so fast? If you are the parent of a girl, most likely it won't take a lot of convincing to

come in for senior portraits and to enjoy having them done. If you are the parent of a boy on the other hand, you may have to appeal to their sense of undying love of their parents to get this done. It is hard to convey to a 17-year-old that their adult life is going to go by so fast and that these portraits will be important to them in the future. So as opposed to just beating them over the head and telling them they have to do this, when you show them how unique, fun and all about them this session can be—(many teenagers are very self-centered; if your baby is still "all about mom" well, just you wait!)—it can turn even the grumpiest of teens into a willing participant. My favorite activity is showing them how awful senior photography was when I was young and telling them how lucky they are to be a senior now!

Senior portraits present an interesting series of fears and objections. Up until this point, the parents are the only ones really making the decisions about the portraits of the child. Now that this child is a senior in high school and full of opinions themselves, there are only a few sets of opinions that matter. The fear I have found for most parents is that their senior won't enjoy their portrait session. The fear I have found for most seniors is that they won't look good!

I photographed Emma's two older brothers for their senior portraits, and I knew once Emma became a senior she would be coming to the studio. When she was around 14, she came in for a few cheerleading portraits, so I was already looking forward to capturing her lovely smile again.

We photographed her senior portrait session in two parts, one part at the studio and one on location at Phillippe Park in Safety Harbor. Several years ago, Emma and her brothers lost their father from injuries sustained while serving in the war in Afghanistan. For each of their senior sessions we incorporated a piece of his memory into their portrait so that he would not only live on forever in their hearts, but also in their senior portraits. For her portrait, Emma chose to cuddle the bear he had given her, such a special gift that she now holds close to her heart to represent her love for her daddy.

Emma is a stunning young lady and her session was nothing short of spectacular. Sometimes the stars align and each click of the shutter produces a work of art. Together we pushed each other to keep creating until the sun would no longer allow us to continue. Her mother and grandmother ended up purchasing an album and several pieces of art for their home. I fell in love with one of her images in which she is wearing a flowing dress and chose to take it one step further by painting it and adding the finished painting to the front gallery of the studio. The portrait is stunning and everyone who walks in the studio comments on how much they adore it. I love sharing Emma's story when people ask!

It isn't usually difficult to get girls interested in having their senior portrait done. Most teenage girls love having days all about them, going shopping for the perfect outfits and having their hair and makeup done. Boys are a different story, however. When consulting with the moms of teenage boys about senior portraits I hear a lot of, "Yeah, I have to force him to do this," or "I am thinking one outfit will be plenty because he doesn't even want to do that." That being said, I do have a lot of boys who love coming in for their portraits and truly get into the spirit of the session.

Either way, the key I have found to getting a boy excited about his session is to assure him we will focus on his interests and passions. These aren't going to be boring, stand- here-and-look-at-the-camera images (well some of them will be for the yearbook, but we don't emphasize that when talking to them! Shhh). Boys have interests that are as wide and varied as girls; sports, cars, music, computers, I've even had a senior bring his drone! Once I get them talking about what they love, the tone of the consultation changes and I hear the gears turning in their heads.

Daniel came to the studio for his senior portrait with his suit for the yearbook, a casual outfit and his football jersey. I couldn't tell at the beginning if he was excited or not about the session but having photographed his older brother and knowing his mom pretty well, I knew he would at least be cooperative! Daniel looked amazing in his suit and wore it well. He went very GQ with his yearbook poses and while he didn't smile a ton, he rocked the serious, intrigued look. Once we got outside with his football jersey and his jeep he lit up. Now that we were photographing what he loved, his car, we moved through concepts and poses quickly as he was fully engaged. The finished images were perfectly Daniel and he loved them!

So how do you plan for this senior portrait? Do you want to use the school photographer, or hire a photographer for your own session? Many schools have contracts with a specific studio in order to compile their yearbooks in a consistent and timely manner. That photography studio may be amazing or they may not be. As a parent, it's helpful to consider what you want out of your child's senior portrait (will it hang over the mantle until it's replaced by a wedding photo?) and then determine whether to use the school photographer, or have a private session, or do a little of both (the basics done by the school, and then a supplemental session with a different photographer). It all comes down to the vision you and your graduating child have.

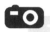

Tips For Photographing The Perfect Senior Portrait:

Chat with your teenager about what they are most interested in having documented. It may be as simple as having a portrait done in their favorite outfits or they may want to showcase their collection of award-winning drawings and everything in between.

Meet with your photographer either on the phone or in person to plan the perfect session. If this will be a fashion session for your daughter, hair and makeup will become a priority and must be scheduled along with the portraits. If this is a sports shoot for your son or daughter, you will need to obtain their uniforms and equipment from the school in time for the session.

Select at least one classic, timeless outfit for the session. For boys this is still a suit or at least a shirt and tie. For many boys this may be their first time wearing a suit, but it won't be their last and it definitely marks their transition into adulthood. For girls, a classic dress or pants and top that steers clear of today's trends and you could look at in 30 years and have no idea when it was photographed. (In other words, not the bright, fluorescent, crazy-patterned dress

I wore in my early 90s high school portrait that screamed "Fresh Prince of Bel-Air.")

Schedule the session over the summer. I know this seems like a pain and super early in the school calendar, but trust me when I tell you that once school starts it is a race to the finish line and your child will be so over-scheduled it will be hard to coordinate an appointment between them, you and a photographer.

Budget to spend money on this session. Remember, this is the last and final milestone of your child as your child. This is the perfect time to have a wall portrait created to hang in your home. When they have moved away to college or wherever life brings them you will have their senior portrait hanging on the wall to smile at when you are missing them.

Chapter 9:

Family Ties: Sibling, Family, Grandparent, and Pet Portraits

> "The more children know about their family's story, the stronger their sense of control over their lives, the higher their self-esteem, and the more successfully they believe their families function. Knowing their larger family story helps them understand that they are part of something bigger."
> – Bruce Feiler, The Secrets of Happy Families

Up until now I've been focused on the individual child and capturing their milestones. In this chapter, I'll go over the whys and the hows of adding a sibling, the family, the grandparents and yes, even the family pet to your portrait collection. These types of portraits are essential to capturing a comprehensive photographic history of your family.

The Sibling Portrait

While most of this book focuses on the individual childhood stage, I would be remiss if I didn't spend a little time talking about the sibling

portrait. As a parent focused on documenting the ages and stages of your children, photographing them together is just as important as photographing them separately. Together siblings bring out different personalities in each other and relationships that are truly unique to each sibling group.

I have found that many families who are "religious" about photographing child number one, tend to not be so as much with child number two. While they may still come to have the matching milestones captured for the baby's first year, life and obligations get in the way when you add in another child. This happens for many reasons. With your first child everything is so new, highly anticipated and fascinating and you can focus 100% of your energy, time and money on this one child. When you have a second child, while the love and anticipation is there, now your time and energy must be split between children, and your investment in portraits must be shared as well.

Working with children of any age presents its own unique set of challenges. When you add in multiple children then you have multiple ages, personalities and sets of eyes and feet you need to control! Now imagine twin two-year-olds and you can see why I jokingly say that photographing children is my daily cardio.

I vividly remember when Allie and Sarah came in for their two-year portraits. Their mom warned me ahead of time that they were full on in their terrible twos. Luckily, she brought their nanny to help wrangle the children and I had my assistant. We outnumbered the kids two to one and we needed that advantage; just as we would get one twin to sit, the other would jump up and run out the door. Then we would get one licking a lollipop and the other would be swinging it around like a sword eventually smashing it to smithereens. In the end we did create a beautiful collection of images and stories that this family will surely bring up with the girls when they are teenagers!

In many families once their first child hits about two or three, they begin thinking of having another child. Of course, since there are so many factors at play in the building of a family, I can't even sit here and tell you there is a norm. I have had clients with babies that are 10 months apart spanning all the way to 18 years apart. My own children are spaced out by nine years. There is honestly no one age range that is better than another. They all have their pros and they all have their cons. In the end it is the number of children you have, and their age range that makes your family unique and special.

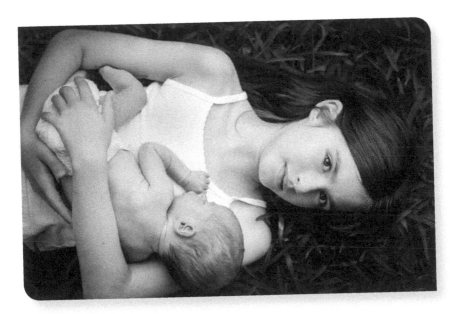

The first sibling portrait is an important one. This is usually taken the first time the only child welcomes home their baby brother or sister. Even if the older sibling is only two, there is usually a look of awe and wonder that is precious to capture. It may literally only last for a matter of seconds before that toddler decides to roll over this new baby, but keeping their attention span in perspective, that is all we need to forever remember that feeling.

I love having siblings of all ages in the studio. I love creating something new and each set of siblings that comes before my camera always brings a new dynamic for me to work with. Are they serious, are they silly, are they going through a phase where they dislike each other and are fighting all the time? Are they the best of friends or do they look at each other and stick their finger an inch away from their brother's shoulder and say, "I'm not touching you!"? It honestly doesn't matter what phase of "love" your children are at with each other, it is what their childhood is about, and it's all important to remember.

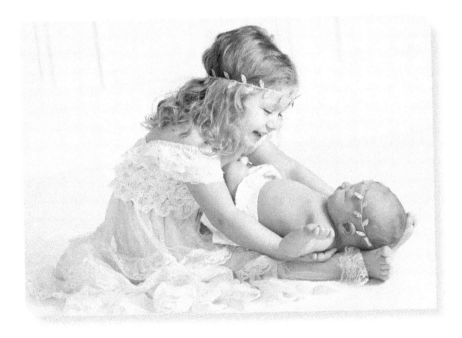

When siblings come to the studio, I always photograph their relationship, but then I suggest photographing them alone as well. Sometimes once we become a larger family we tend to forget about the individuals within. While it is important to capture the togetherness of your children, it is also important to capture their individuality. If you think about these portraits as something you will be passing along to your children in the future, they

will want to have a collection of images not only with their brothers and sisters, but alone as well. After all they need something to put in that slideshow at their wedding reception some day!

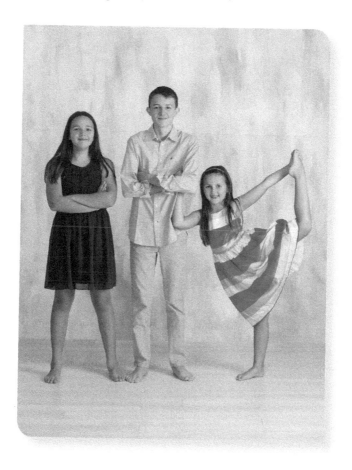

Just as an individual child's personality and development changes over the years as we photograph in the studio, so does the sibling dynamic. One year they may be all lovey and want to hug and give each other kisses, and then the next year they don't want to be near each other at all, let alone touching! While one reaction may be more endearing in a photograph, they are all natural reactions and part of the growth of our children. The parents and I may try and suggest a hug or otherwise sweet

image, but I will always take the real-life image as well. You never know which moment you will want to remember!

Recently I photographed a multi-generational family. When photographing the grandparents with just their three sons I noticed that they were standing on their tippy-toes and laughing at each other. Of course, I took an image, but then I had to ask what that was all about. The father laughed at me and shared that it was sibling rivalry. Yes, even at 40-something these two brothers were joking about who was taller. The dynamics of our relationships with our brothers and sisters may change over time, but they are always rooted in our relationships as children. When I saw these two men laughing and trying to get taller than each other I could picture them as teenagers competing to see who was growing the fastest. These little moments are special and part of what makes you smile and chuckle to yourself when you reflect on your life.

Tips For Photographing Your Sibling Children At Any Age:

Choose simple outfits that complement one another. They don't necessarily have to match exactly. Keep them simple—it's hard enough getting every child looking in the right direction, you don't want to have to be messing with hair bows and accessories at the same time.

Focus on the children together but also take the time to create individual portraits of each child.

Create images that are not only representative of the children at this age and stage but also capture their personality together as a group.

Family Portrait

Family portraits are always an event! And of course, some of these events are more interesting than others, depending on the age of your child.

Look at a two-year-old in a family portrait, for example. Most times in a family portrait we are working to have everyone in a single spot, sitting or standing and looking at the camera or each other. None of that seems too difficult to achieve until you add in the emotions of a two-year-old. It is funny how they love being held by a parent, until you ask that parent to hold them for a portrait. Then all of a sudden it would appear their parent's hands are made of spikes and are causing pain and all they want to do is get down.

When Olivia came in for her family portrait session, we knew we were in for a bit of a challenge. While a sweet and innocent baby throughout her entire one-year milestone plan, Olivia started to express her independence at her smash cake session and then again at her Christmas session. Mom, dad, grandparents and siblings were all prepared for the adventure that was going to be this family portrait. Grandma and Grandpa had come from up north to visit Florida for a few months so we didn't want to miss out on this important opportunity to photograph them with their daughter and grandchildren.

We started off the session with everyone together and holding Olivia. This worked for about five minutes, right up until she decided it would be fun to run instead of being held. For the next 10 minutes we chased Olivia up and down the boardwalk trying to trick her into standing with her family.

Finally, I started to laugh. I told everyone to just stand there and pose and I would photograph Olivia running away from them. We took the photo and bam! It is my favorite image in the entire group! Why? Because it is so true to family life with a two-year-old! Of course, we have the important memory-keeping images with Grandma and Grandpa, but the image of her running away will always be what they remember of as Olivia from that age and how their family responded.

As parents, time is our enemy. From the moment we give birth to our first child, the clock is ticking on when they will leave home and begin their own journey.

No matter what we try to do, we cannot slow down time. During the 18 years we have our children in our homes, we want them to grow and learn to become independent thinkers, we want them to believe in themselves and become secure in who they are, and above all else we want them to feel loved and that they belong to an incredible family.

This is why I believe so strongly in the importance of a family portrait. When you share an experience of photography together as a family, and then proudly display the finished portrait in a prominent place in your home, you are telling your children and everyone else that nothing is more important than your family.

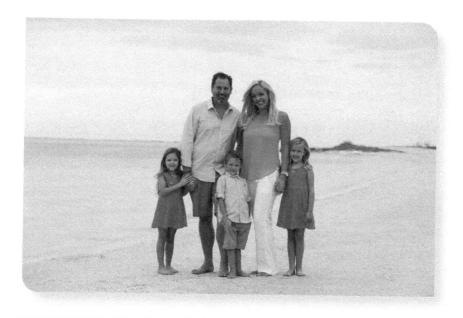

The family portrait allows time to stand still for the moment the portrait was created.

Everyone in that image will look at it and know they belong to something special and remember the stories of that time in their life. I always encourage the parents to journal a memory or two about the portrait day in a

card we provide on the back of the frame. This will ensure no memory is forgotten and, as an added bonus, will also preserve your handwriting for future generations.

Knowing the importance of the family portrait, I also understand how difficult it is to pull off. It is hard enough to get the calendars for mom and the children to align, but now you add dad into the portrait as well and it can take a small scheduling miracle to happen. When something is as important as the legacy of your family, finding the time to make it happen should become a non-issue: you just do it.

"When is the right time for a family portrait?" This question is asked of me at least daily in my studio. The answer I give is usually, "if you are asking, then it is probably the right time." The reason I say this is because honestly the only wrong time is when it is too late to capture a moment that is now lost. You don't want your family legacy to be a series of missed opportunities. That being said, there are some key timing factors to think about when planning a family portrait:

- **The age of grandparents.** While our children continue to get older, our parents aren't getting any younger. Ensuring your children have portraits with their grandparents is so very important. Don't wait for the perfect time or when you think your family is "complete." If you have the opportunity to get your parents in a portrait with your children, do it now!

- **Before a child leaves for college.** Once your child leaves for college, their life is their own. Retrieving them for a family portrait becomes difficult and often won't happen until they get married! This is such an important time in their life and your history as a family.

- **The addition of a new child.** I often find clients telling me it has been 10 years and two children since their last portrait. I know they say it with a subtle laugh, but how awful for the two children not hanging on the wall as part of the family! What does it say about them? Their family is too busy for them? They aren't as important as their older siblings? While time may often be an issue, you can't send these messages to your younger children that they aren't worth the time or investment to include in a family portrait.

- **Wedding Anniversary.** Oftentimes I find families scheduling a family portrait around a significant wedding anniversary of the parents. It is a gift they give themselves, taken when extended family is visiting, and is a historic marker in the timeline of the family history.

- **Minimum, every 5 years.** If you are struggling with when to schedule a family portrait and the above items don't spell it out for you, then go with the fall back of every 5 years. This will ensure you capture each of your children as they go through significant milestones in their own life and also tell a beautiful story of the growth and change of your family. Below you can see this sweet family and how they have changed in only 4 short years.

2014

2018

Grandparent Portrait

Throughout the past 15 years of my photography career I've always had a soft spot for families who want to involve grandparents in their sessions. Looking back at my own life, I have very few photographs of me with my grandparents. One of my grandparents died before I was born, the other two died when I was still quite young and the other just never took a lot of photos. This might be why I treasure so much a photo of me at age two sitting with my grandfather on a park bench. He passed away shortly after the photograph was taken. I know from the stories my mom tells that he loved me very much and I hold onto this image to help me remember that for my first few years he was a part of my life every day.

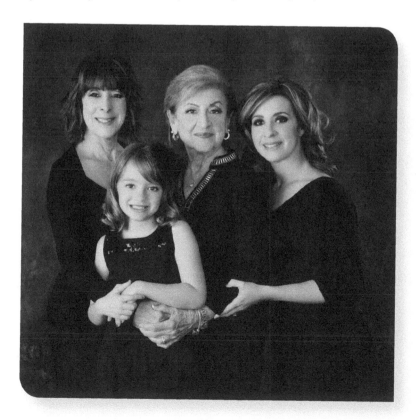

I know it isn't always easy to convince a grandparent to get in a photograph. They don't always feel "camera ready." I try to convey the importance of being in a portrait for the sake of their grandchildren. These photographs will help keep the memory alive of their time spent together. The photographs taken of grandparents and their grandkids become their legacy. I believe that these photos are so important that every chance I have at occasions such as birthdays and holidays, I make my kids pose with their grandparents for a photograph or two. While I can't always get everyone in the studio, I know that at least I have these candid or posed memories to keep for my children.

When is the right time to bring a grandparent to a professional portrait session with your children? Without sounding morbid, the best answer is as soon as you can make it happen! Nobody is guaranteed a tomorrow and as our parents age it is harder and harder to get them photographed. It is important for children to know they are loved, that they belong and also where they come from. All of this can happen in the creation of a multi-generational portrait.

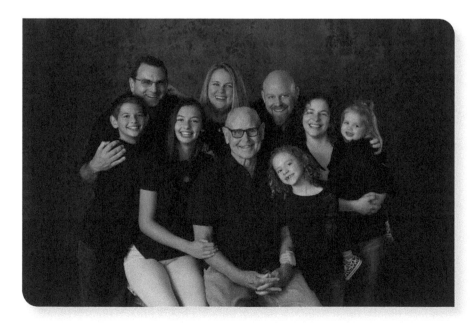

Tips For Creating The Must-Have Grandparent Portrait:

Tell your parents that their grandchildren want to have this portrait. Grandparents have a hard time saying no to their grandkids.

Choose simple colors that your parents won't object to. Keep the shopping to a minimum. Have them wear long sleeves—they will like their images more this way.

Schedule to have the portrait taken during a special occasion. Typically, grandparents are already in the mood for family time during a birthday or holiday and this can be an activity that is organically woven into the event.

Pet Portrait

I would be remiss in writing a book about photographing the life and story of your children without talking about your four-legged children as well. For many families their pets are just as important to their story and legacy. Pets provide our family with unconditional love and companionship while teaching responsibility.

The most common pet included in a family portrait is a dog, however I have had cats, birds, fish and even horses photographed along with the family. A successful photograph usually depends on how well-trained the animal is and how we can work around their size and demeanor. If the pet is important to your family, then it should be important to your family portrait. Their presence in at least a few of the images from the portrait session help to tell the story of that time in your family.

Many Americans are getting married later in life and even after marriage they sometimes wait several years before having children. This

often leads to the family pet being their "first child." This was the case when Katie and Dan came to the studio. Their dog, Luke, had been their fur-baby for years and now it was time to welcome a new, human baby home. During their newborn session consultation, they told me that Luke has been their entire world and how important it was to include him in their newborn session. Together we brainstormed a few adorable ideas and scheduled the timeline of the session around Luke posing with baby Madison. One image in particular focused on the humor of Luke asking Santa to take back his Christmas present. The expression on Luke's face is so perfect! This turned out to be our favorite image from the session.

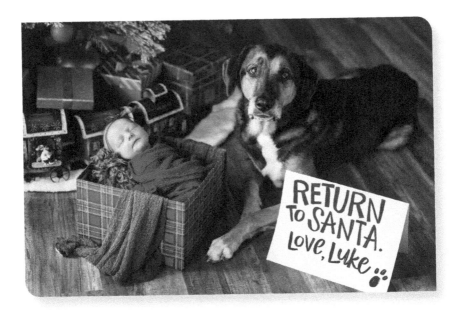

You may have heard the old Hollywood adage "never work with children or animals" (as attributed to W.C. Fields) so you can only imagine the challenges that you and your photographer will face when you combine both into the same image! When I know a family pet is going to be added to a session I always talk at great length about how we will manage the time, the animal and the children. The biggest key is to just have fun and

try not to expect the perfect outcome. Magic always happens, and just as I am all about capturing the essence of children, I'm sure to capture the essence and personality of your pet!

Tips For Adding Your Pet To Your Family Portrait:

Be sure to let your photographer know. Please do not just show up to your session with a car full of dogs if you did not forewarn your photographer! Photographing people and animals requires special planning and notice.

Bring treats and toys. Much like children, pets need to know when they are doing good, and occasionally require bribes. Bring their favorite treats as well as toys to keep them doing what we need them to do.

Be prepared for the unexpected and imperfect. Oh sure, the stars may align and your two, five and 10-year-old along with two dogs

may all stay in one spot and look in the general direction of the camera, but be prepared when this doesn't happen and embrace the fun story that will go along with the images.

Tire your dog out before the session. This is the opposite to working with children! For children we want well-napped, awake and happy kids. For dogs that have a lot of energy, we want them tired and wanting to just sit next to their family. Assign someone in the family (usually dad), to run the dog around and get their energy out while everyone is getting ready.

Chapter 10:

Religious Milestones

For many families, religious milestones still feature prominently in their lives. These milestones are another way of marking your children's development and progression through various rites of passage. In this chapter I'll discuss the more common religious milestones I capture for families. Making a portrait at these times is a beautiful addition to the family photographic history and always summons a memory of the day, while also reminding the family of the value of religion in their lives.

Baptism / Dedication

A baby's baptism is a tradition that welcomes them into the faith of their parents. There are a lot of traditions based around a baptism and there is always a special outfit to be worn.

Most baptisms happen within the baby's first year of life making this the perfect opportunity for a formal baby portrait. I recommend parents bring the baptism outfit along to their closest milestone session or as part of a stand-alone baby session if they are not in a first-year milestone plan. While these images are typically more traditional and formal than most parents are looking for in a modern baby portrait, I believe they are too

important to skip over. As the first religious milestone for this child it is well worth documenting with a portrait fitting the mood of the occasion.

One baptism session I did became my favorite because of the dress the parent had for their baby. When the mother unpacked the dress from the garment bag, I was stunned. I had never seen such an intricate baptism dress! The grandmother told me the story of how this dress came to be. It began with her great-grandmother. When she was born, her mother took part of her wedding gown to make the dress. When she became a parent and had her first daughter, the grandmother, she then took the dress and added to it from her own wedding gown and the tradition was made. Since then, the baptism dress has been added to by both the grandmother and the mother of this baby girl. The dress this baby was

about to put on was hand-crafted from the wedding dresses of four generations of women in her family. I felt chills run up the back of my neck as the grandmother told me the story. What an incredible gift these ladies have passed on to their daughters!

This portrait we created not only tells the story of this little girl's first baptism, but also ties her to the generations of women that came before her.

First Communion

First Communion is a ceremony in some Christian faiths, most commonly the Catholic church, in which a person receives their first Eucharist. It is the third of seven sacraments received and can occur only after receiving baptism and once a child has reached the "age of reason." For most children this happens around seven or eight. It is a holy and joyous occasion where the soul of the person becomes the bride of Christ. This is why girls wear white dresses and boys wear suits.

My family is Catholic and growing up in my home there were framed photographs of both of my parent's First Communions. This is quite remarkable considering my dad grew up during the Depression, and there were not a lot of photographs taken during his childhood. A First Communion however, was a special enough occasion for my grandparents to have spent the time and money to document for each of their seven children. My brother recently found another photograph from our father's First Communion while going through some old boxes. None of us had ever seen it before and unlike the formal image we have framed, in this one my dad has a big grin. Not only did this allow us to see a happy side of our father as a child, but the craziest thing is when looking at that photograph all I could see was my son James – they have the same smile! Genetics are amazing and I never would have seen that similarity without that photograph.

Many churches provide photography the day a group of children receive their first communion. It is a big deal and worth taking a lot of photographs! However, I have found that many families want to also celebrate with a special portrait session at the studio. In an hour we can create a series of beautiful portraits of not only the child in their first communion dress or suit, but beautiful family portraits as well.

Bertha first came to my studio when her second daughter, Tica, was born. She joined the baby plan and I have had the pleasure of documenting Tica through all of her baby, toddler and childhood milestones. By the time she came in for her First Communion portraits it was an emotional session for both Tica's mother and I! After all, I photographed her in her baptism dress as a baby and now here she is standing in a beautiful white

gown for her First Communion. We joked that the next white dress we would see her in would be her wedding gown. While half-joking, I know that day will come faster than I care to admit, although I told her mother I expect to be a guest at her wedding and not the photographer as I hope to be retired by then!

"*Our family and faith are two of the strongest and most important things in our lives. Being able to celebrate, cherish and share it are the other three we love to do. Cloud 9's family style treatment with a personalized yet professional touch, gave us the opportunity to share these memories of Tica's First Communion and keep them in our hearts forever.*" – Bertha

Bar or Bat Mitzvah

A Bar or Bat Mitzvah is the religious initiation ceremony of a Jewish boy or girl who has reached the age of 13 and is now ready to participate in public

worship. This is a tradition that runs deep in the Jewish faith and families take a lot of pride in. The parties thrown for a Bar or Bat Mitzvah have rivaled some weddings I've been to! Many families will opt to hire an event photographer to attend the party and capture memories of the ceremony and party. Photo booths are also very popular and the children love getting silly while also dressing up. After all, this party is 13 years in the making!

As a portrait photographer my job is a bit different. A family will typically hire me ahead of the party to create a very traditional, classic and sometimes painted portrait of their child. As with most coming of age milestones it is the one that has been marked with a traditional portrait in their family for the past few generations. Although I put a modern spin on the approach to the portrait session, the emotions and mood behind the finished piece is definitely a classic portrait that will stand the test of time.

When selecting what your child will wear for the portrait, stay traditional and classic to respect the tradition and take it seriously. Remember this portrait will hang in your home forever and then eventually in your child's home. At 13 your child is old enough that you shouldn't have to worry or stress about how they will act at the portrait session, so breathe and relax. This should be a bonding time and an enjoyable experience for everyone. Save the stress for seating arrangements and food after the ceremony. Choose colors that look good for your child and also will display well in a home. Once you have the formal portrait taken care of, think about other ideas! Family portraits are nice to have and relieve a bit of stress from the day of the party. Also keep in mind your child's activities and obsessions. While this isn't their senior portrait we can certainly mix up the session and capture a few fun ones too.

These are the most common religious milestones that I photograph in my studio, however I know there are many others. Regardless of the religion or age my advice remains the same to families looking to have portraits for these occasions photographed.

Tips for Photographing Religious Milestones:

1. **Don't skip over having a formal portrait made at this time.** While your place of worship may provide event photography, and I definitely recommend you take advantage of that, you will also want to have planned formal portraits of this milestone where you have time to be photographed in a relaxed environment.

2. **Pay attention to the details of this portrait.** Bring whatever religious elements are appropriate (for example a bible or rosary beads) with you to your session. Do not assume your photographer has what you want (and even if they did the images will have more meaning if you are using your own pieces.)

3. **Consider being a part of the session for at least a few poses.** This is a memory your child will not have without a portrait to tell the story, imagine how much more special this story will be if their parents are a part of it.

4. **Figure out a way to tie the past into the present.** Religious milestones are typically ones that tie generations together. If you have something from when you or a grandparent celebrated this same rite of passage, incorporate that in to the session.

Chapter 11:

The Most Wonderful Time of The Year: Holiday Portraits

> *"We are better throughout the year for having, in spirit, become a child again at Christmastime."* -
> *—Laura Ingalls Wilder*

We take so many photos during the holidays that it's easy to think we've got it covered. Still, every Christmas families love to sit for a portrait to go on their cards. Halloween and Easter also offer fun opportunities for unique portraits. Sitting for a holiday portrait, no matter the holiday, is a beautiful way to capture the memories of a special time. In this chapter, I'll discuss best practices when it comes to creating magical holiday portraits.

Christmas

Melissa has been coming to the studio for the past six years with her son and daughter. Each year I see her putting more and more pressure on herself to make sure everything is perfect, from finding the perfect

coordinating outfits, to ensuring her youngest has had a nap and is well-rested. Her husband has always teased her, but never objected to the portrait sessions throughout the years.

After their Santa portraits this year, Melissa emailed me that she and her husband were talking about the portraits as it was his first chance to see them since they were created. Reminding her husband of the hard time he gives her every year to get these photos done, Melissa approached him wanting to know if he believed it was worth it now that he had seen the results. He replied to Melissa, "I promise you that I am not just telling you what I know you want to hear, these are worth it. They are amazing. Jeanine does it every time. I absolutely love them. We will have these when we are old and grey and none of our children come home for Christmas!"

This was one of the best emails I have yet to receive from a client, seriously. It is always so validating to hear both parents comment on the portraits. I know that my mom clients always see the value instantly, but it's not always something I hear from the dads. When I receive compliments like this from both mom and dad, then I know I'm doing something right.

Christmas is the most wonderful time of the year, Andy Williams even said so! As a children's portrait photographer, it goes without saying that the months of October-December are my busiest months. In fact, I make a pact with my family when October begins that if we make it through to the other side of December alive we will go on a special trip where mommy brings zero cameras and electronics (of course with my iPhone I can sneak a photo every now and then, shhhh don't tell on me!)

The Christmas Portrait, like so much in the photography world, has become a source of joy and yet also a source of stress for so many parents. While many people will put off birthday portraits, or other "minor" milestones throughout the year, the looming task of sending Christmas Cards and finding the perfect gift for grandparents typically draws parents to a photography studio in the later months of the year. Along with this comes the stress of finding the perfect outfits, scheduling a session that doesn't interfere with mom and dad's work schedules, the kids' sports or school and of course coincides with an open time with their photographer. I recently asked a group of my clients what the biggest struggle was with coming to the studio at Christmas. The overwhelming response was: 1) the attitudes of their children followed by 2) finding the right outfits and 3) naps.

What if I told you that 20 years from now, you won't remember if Emily's shoes weren't the right shade of red or that Luke's hair got rumpled when his sister hugged him too tight? What if I told you that the photo of Cason laughing at his little brother while he is trying desperately to open the box I gave him would become your favorite over the one of them both looking and smiling at the camera? What if I told you that the photograph of Matthew crying on Santa's lap will bring you years of smiles and laughter and that you will forever be able to retell that story to anyone who will listen, no matter how old you are? What if you could just trust me that all of the stresses you are putting on yourself at this moment to create the perfect holiday memory are unnecessary and that everything that is important is sitting right there on your lap when you are cuddled up reading a bedtime story?

Whatever stage your children are going through is the perfect stage for this year's Christmas portrait, and the clothes, the attitudes and the nap schedule will all happen with or without you requiring medication to make it through the season!

Hopefully this section will help ease some of that stress. First of all, you must understand that the main purpose of the Christmas portrait isn't to portray the perfect family on a card to your friends and family. The purpose is to have memories that you can bring out year after year with your holiday decorations. For you to be able to look back on the years your children believed in the magic of Christmas with a wonder and joy that brings a smile to your face. Each year when I take out my box of Christmas portraits to display around my home I am flooded with the memories of my children at those ages. There is one image of my daughter sitting on the floor playing with Santa and a train. It is one of my favorite images because she is looking into the eyes of a man she fully believes to be magical. I am instantly transported back in time to her laughter and excitement of seeing Santa that year. I'm reminded of what she wanted for Christmas,

and how we couldn't drag her away from the studio while Santa was there. Most of all, I can still close my eyes and see the look of awe on her face when she walked into the living room that Christmas morning.

Christmas itself brings about feelings of nostalgia. I may be the only crazy one, but don't the memories of Christmas past always just seem to be tinted slightly a different color? Almost like during a flashback in a movie. At least this is how I see my childhood Christmases in my mind. I remember family gatherings, lots of food, baking cookies, opening presents and above all time spent with my parents and siblings and cousins. My mother used to make Christmas scrapbooks every year and we still flip through them today and reminisce about the years gone by.

In our studio I try to help parents remove the stress of clothing and attitudes by theming all of our holiday sets to be fun and interactive for the kids. With each theme we help the parents come up with outfits to wear and create style guides to help with shopping. I want to help create happy memories for parents to share with their children so that the photography session not only produces portraits but also stories they can tell for years.

Like the time little Zachary came running so fast onto the set that he plunged right into the fake snow and took down three of the gingerbread men. It has been eight years and his mom and I still laugh about it even as he rolls his now pre-teen eyes at us!

The fear all parents have about spending time, money and energy into bringing their child in for a portrait session and it being a failure rings true at all times of the year, however at Christmas this is even more the case. Between having the pressure to create a Christmas as magical as the ones you remember as a kid to having the perfect Christmas card photo, it is enough to make any mom just want to skip the stress and drink a glass of wine.

Nobody's walking out on this fun, old-fashioned family Christmas!

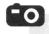

Keep in mind the age of your children and hold realistic expectations for what they are able to do at this stage. If they are two, you may want to accept in your mind that they may be afraid of Santa Claus. If they are toddlers, select a holiday portrait session that has something for them to do, treats to eat, props to play with etc. Keep their little hands busy and the smiles will come naturally. If you have teenagers that don't think Christmas is cool anymore ... well then do what you must to get them on board! They can be stuffy ol' adults soon enough, for now they can still be kids.

Shop early and try clothes on prior to coming in for the session. I cannot emphasize this enough! This year I had a client text me at 6 am from a 24-hour Walmart where she was looking for the clothes for their session *that day*. Holy cow ... I was nervous for her so I can't imagine how she felt! With Amazon, Etsy, Zulily and many other online resources you can pretty much shop for holiday clothing year-round. As soon as you know what your plans are for your session start shopping!

Schedule your session early. If your plan is to have your portraits ready to send out as Christmas cards and give as gifts, you need to schedule your Christmas Session with plenty of time to make this happen. In our studio we schedule all of our Christmas themes in November and encourage family sessions to be completed in October.

Relax and Breathe. I know this sounds basic, yet it is so hard. I can't tell you how many times I hear parents walking through the front doors of the studio already yelling at their children and I haven't even had the chance to say hi yet! Kids can pick up on your stress. The younger they are the less they are able to process that anxiety and so they themselves become upset. Breathe and trust your photographer. You hired them for a reason so let them do their job.

A well-seasoned portrait photographer will warm up your children to the camera and create the images you want. Don't make our job harder by yelling at your children before or during a session. Remember the true reason you are having these portraits made is to have a memory of your children and family at this age. Embrace the true reason and let it set you free from at least one of your holiday stresses.

Easter

While it is easy to explain why Christmas is such a popular time of year and holiday for photography, less easy to explain is why a Christian holiday celebrating the resurrection of Jesus Christ has become the second biggest holiday for portraits. All the same, it's a popular time for portraits around the studio.

For much of the US, Easter is the first spring holiday; a time to break out your warm- weather clothes and say goodbye to winter. As Christians wear their best clothes to church on Easter, why should that outfit only get one use! Easter parades and other ways of celebrating this holiday have become tradition and thus so has the Easter portrait. Easter and Spring both have a focus on re-birth and this makes it a special time for parents with their children, especially first-time parents.

Very early on in the studio I noticed that in the spring, clients were always requesting Easter portraits with bunnies, chicks or ducks, essentially some sort of baby animal associated with the season. Once booking a session they would bring their child in their finest spring Easter outfit to sit and play with a farm animal.

I have always loved Easter portraits and, in our area, I have become known as the Baby Duck lady. Each spring we bring baby ducks to the studio for two weeks and I design uniquely themed sets for the babies and children

to be photographed in their finest Easter or Spring outfits with the ducks. Watching the expressions on the kids when the little baby ducks peep or waddle towards them for the first time is priceless and always makes for precious portraits.

Photographing with baby animals should be taken very seriously and only be done with a photographer who is well-trained and has the proper licensing. Each state has different laws and permits required for photographing various animals, something you should be aware of before having your baby or child photographed. (For example, in Florida, we don't need a permit because the ducks are considered water fowl.) We have been photographing with baby ducks for over 10 years and while at our studio these little quacking cuties live in luxury in our Ducky Day Spa. We have the warmest of beds for them with fresh shavings throughout the day for their little feet to waddle on and plenty of food and water. Ducks love human company and we handle them with love frequently throughout the day. Eryn, my daughter, often camps out at the studio during duck season and chooses her favorite baby duck. Did you know that ducks can imprint on humans? I swear this has happened more than once at the studio. One year, Eryn chose her favorite duck and named him Rocky. She carried this duck with her everywhere and within a few days Rocky would follow her wherever she went, and peep when she wasn't around.

Parents are always stressing to find ways to capture the true smile or expressions of their children that they know are bottled up inside. The ones you see when they are playing around and don't think you are watching, but that go away the instant you bring out your camera. The smile that lights up a room and giggle that melts your heart. Most children are not models or actors, and when you tell them to smile for a picture they give a fake pained expression. WHY?!?! WHY?!?! I too have been known to yell at my 11-year-old "for the love of all that is holy, please just give mommy a real smile!" Trust me—that usually doesn't work, and I don't recommend succumbing to begging, threats or yelling. It is hard, I know.

I know this "real smile quest" is why our baby duck portraits have become so popular. Not only is it an experience everyone in the family loves but you don't have to beg your kids to give you a real smile, they come naturally when playing with these adorable fuzzy little yellow creatures. Over the years I have learned exactly the perfect script of poses and interactions with the ducks to make even the most stubborn of children giggle and smile for real.

Parents of multiple children also rejoice at the baby duck sessions because this is the perfect way to get all of their children to focus on the same subject for a photograph. There is no one child looking left while another is looking right and still another looking God knows where. All of the children will look at the ducks to play with them or look at me when I direct them to.

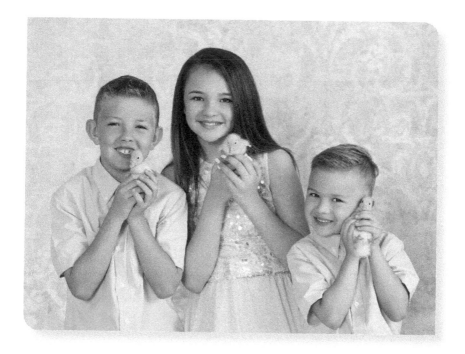

How much do the kids love the ducks? If a child has been photographed with the baby ducks, the next time they come back to the studio they always ask me "Ms. Jeanine, are the baby ducks still here?" It doesn't matter if it has only been a few weeks or a few months. They don't forget the fun they had and they are hoping for another dose of duck cuddles.

Just like Christmas, Easter is a time to change out the decorations in your home. Most of my clients decorate in March and April for Easter and will go around switching out many of their table top display frames to their

baby duck portraits from years past. Now you get another time during the year where you can look over a collection of annual portraits and remember the stories of your children and what they were like, what they said and how they played with the ducks.

Tips for Planning Your Easter/Spring Portrait:

Pick comfortable clothing for babies and young children. While the tiny suits, sweater vests, bonnets and dresses will be filling the aisles of local stores, if the outfit is itchy, or your toddler doesn't like collars, it doesn't matter how cute the outfit is, they will *not* wear it without a fight. Pick your battles—and this is not a battle worth fighting. Choose an outfit you love that your child will also love. Be prepared to go with the flow and, if necessary, have a backup outfit ready.

As with all sessions, plan around naps and meals. This is especially true if they are being photographed with little animals. At my studio, we cannot bring food or snacks into a session to make your children happy as it isn't safe for the baby animals.

Stick with classic spring colors—even for boys. Don't shy away from pastels as they are part of what makes the spring portrait unique.

Halloween

While Halloween may not seem like a significant holiday, it has certainly taken on a life of its own over the last 10 years. The articles that have circulated on social media comparing Halloween from the 1980s (pillow cases to hold candy and costumes made from bed sheets) to Halloween in the Pinterest era (costumes that take months to plan, design and are perfectly themed with all the siblings, with matching treat bags, and lawn decorations) make me laugh because they are so true!

Remember my clients Jeff and Christina, and their sweet child, Aria, I mentioned in Chapter 1? Well, Christina loves Halloween. Ever since Aria was born, she had wanted to achieve some sort of portrait that incorporated her love of Halloween in with the images. At her newborn session we tried, unsuccessfully, to have Aria sleeping in a cauldron. The poor little thing just wasn't having it no matter how much we cushioned that sucker. It wasn't a comfy bean bag or her mommy's arms and she was not a happy baby. I kept assuring Christina that we would capture the most incredible image for Halloween at some point during the year. When it came time to plan Aria's first birthday session we began brainstorming together again on how we could bring in the cauldron and Halloween. She mentioned loving the movie *Hocus Pocus* and that she had several items at home pertaining to the movie. Perfect!

I had an amazing Halloween background, obviously still had the cauldron, and a ton of black and purple pumpkins from Halloween sets in the past. Over the next few weeks while out and about I kept my eyes open for other items that would complete this set. At Hobby Lobby I hit the jackpot and found mini witches' hats, a broomstick and a black cake stand that would be perfect to hold her smash cake.

I know it is hard when you are a parent and you have this idea of what you want in your head and yet your baby isn't quite ready for that. All I can say is don't rush it. They'll be running all over your house soon enough and then you can't stop them! Well Aria was not going to walk in her session and she wasn't going to stand unassisted no matter what we did. Not to worry—I was ready and we gave her something to stand with for a few images in her "Aria" outfit.

Then, while Aria took a sippy cup break and got changed into her Hocus Pocus Smash Cake outfit, I went to work setting up the most amazing Halloween Birthday backdrop you could imagine. From orange, purple and green balloons, to pumpkins of all shapes and sizes to the smash cake in the same colors, this Halloween-loving mom was going to die of delight when we finished this session. Now all I needed was the baby to cooperate! Please Aria! I said a little prayer to God and asked him to help me on this one. I knew how important it was to Christina to finally get her Halloween portrait and after all, I promised her it would happen at some point and to be patient!

We started off with Aria on the set sitting amongst all the props and balloons. She began interacting with everything and was having a good time. Phew! I was relieved. Now I knew for sure we would create some beautiful images. The magic happened when I noticed Aria peeking in the cauldron. That's it! I had my assistant grab a few mini pumpkins and had her drop them in the cauldron loudly as Aria watched. Of course, Aria's curiosity took over and she had to peer into the cauldron to see what caused that noise. Click! Then she had to reach into the cauldron

to pull one out and throw it back in herself. Click! Next, I gave her the broomstick handle and told her to get the pumpkins and stir them around. And guess what? She did! She put the broomstick in the cauldron and started clanking the pumpkins around. Click! Not only did we achieve our goal, we created magic! I knew after those shots were taken that we finally achieved the perfect magical Halloween portrait of Aria.

As a general rule of thumb, if you spend months designing a costume and hundreds of dollars putting it together, then it is an important enough memory of your child's life that you should have memorable photographs of this costume! Honestly if you think about it, even if you don't go crazy, the memory of what your child chose to be for Halloween (either on their own or with your help) is an important part of their unique story. If you choose to take them to a portrait studio to have a fun themed memory, that is awesome, however at the very least you should be sure to document these important memories at home.

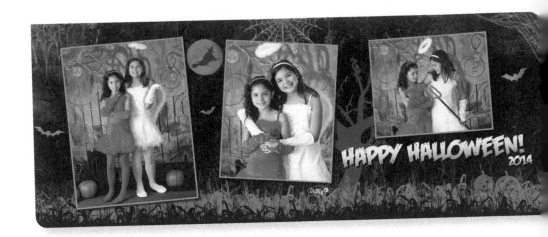

Other Holidays

While the above sections are the main holidays we focus on in our studio, we have also photographed many other religious and national holidays. Most religions have their high holy days and occasions worth celebrating with a portrait of their children and/or family. Holidays such as Hanukah, Diwali, Chinese New Year, and Kwanza are a few that are widely recognized and photographed. Don't let this list limit your ideas! Whatever your religion or nationality, I highly encourage you look at incorporating your beliefs and important holidays into your child's portrait collection. Brainstorm with your photographer ideas on symbols, colors, clothes and props to incorporate into your session.

Chapter 12:

Themed Portraits

Several years ago, I began to notice that my daughter who had always loved coming to the studio to be photographed began dreading doing so. At first I thought it was clearly my fault; I had forced this child to model for me too many times and she is over it! But I knew that when Eryn loved doing something, she could do it over and over again, so why not make photography something she'd love and want to do again and again? I recognized she had hit an age where the idea of posing and dressing up nicely for a portrait was boring to her. I knew that if this was the case for her, it must be that way for other children as well.

I sat Eryn down and asked her what would make her happy to come to the studio, what would be fun? She told me if she could dress up and pretend to be a pirate or a mermaid, like in *Jake and the Neverland Pirates* (her favorite cartoon at the time) then she would love to come! I thought, why the heck not? I could easily design a set around pirates, especially in Tampa where we celebrate Gasparilla every year. For those of you who are not familiar, Gasparilla is an annual event in Tampa where the city celebrates the pirates who attacked the city over a 100 years ago. Strange, I know, but it is a Mardi Gras type of event with parades, marathons, and lots of pirate fun.

That year I designed my first themed set in the studio with a beach background and sandy floor, treasure box, lots of seashells, pirate flags, pirate and mermaid costumes, treasure map, telescope, coins and all sorts of

135

other pirate-like props. I photographed Eryn as my example to see how she interacted with the props, practice poses and expressions, and experiment with the finished art piece.

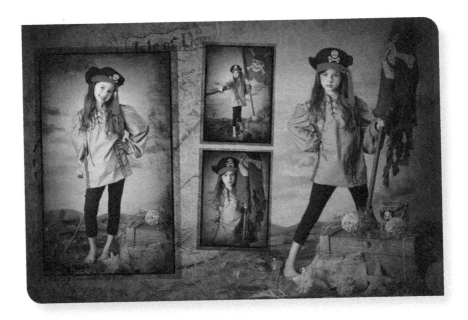

Eryn loved the set. Where in the past it was difficult to get her to put on a dress, brush her hair and look all perfect for a portrait, she was now excited to get dressed up in a pirate costume, tease up her hair, and hold a pirate flag! I directed her for most of the session, and then she had some ideas of her own for fun poses that worked out perfectly (and I ended up using for future sessions with clients!)

This is what inspired me to begin designing themed experiences where kids can dress up and participate in a session that makes them feel like they are part of their favorite movie. To avoid any issues with copyrights and trademarks we are very careful to be sure we are inspired by these movies throughout the sessions, but we don't actually use or claim to use any trademarked materials in the session unless a client brings their own outfits for photography.

Using the images from my test run with Eryn, I marketed this new offering and, sure enough, it was a huge hit! I fully booked my first weekend of Mermaids and Pirates. I was really onto something: the children loved coming in for their sessions, getting dressed up and pretending to be characters they watched on TV or read about in books. This is no longer about coming to a studio for a boring portrait session, this is an experience where children get to role play and imagine life as that character. Parents not only get to enjoy watching their children have a great time in the studio, but they also get finished art for their home that represents a time in their child's life where this character was important to them. I will always remember that my daughter loved pirates from the ages of five to eight. She is now 11 and on to other interests, but those images still hang in our play room as a reminder of her years dreaming of seagoing adventures!

Fast forward five years and now the studio is doing more and more themed portraits. Each year I design a new series of themes and sets to inspire the imaginations of my clients young and old. I have found that wizards and Jedis are extremely popular themes with children between eight and 12. The older the child, the more important these obsessions are in getting them excited about their photography adventures. All of our sets are interactive and allow the child to play and act out the scenes.

Themed portraiture has become a true passion of mine. Not only do I love the artistic challenge of designing new and amazing sets to photograph, and creating the magical effects that we add on after the capture, but I simply adore watching a child come to life in front of the camera because

they are so enamored with what they are doing. I love going over the top with these themes throughout the entire studio so that when a child walks in they are immersed in the experience from the time they open the front door.

Lisa called me after spotting an ad I ran for our Wizarding School Portraits. She had never been to the studio although she told me that she had seen my work through postings of her friends on social media. While she loved our work, she was never inspired to call us to photograph her daughter, Ashley. That is until she saw the images come across her news-feed of a child dressed like a wizard with potions boiling over and magic shooting out of her wand. Ashley was obsessed with Harry Potter, and her birthday was coming up in a few months, the entire theme of which was—you guessed it—Harry Potter!

When I answered the phone, Lisa was so excited and knew that her daughter would absolutely love having her portrait made as a wizard. When I told her that she would get to select a wand from our wand shop, drink our special butter beer, mix potions live on the set, levitate a book, and cast spells with her wand, she signed up right away.

For our wizarding sessions we set up a potion lab in the studio, complete with dry ice for the smoke effect, actual potions for the children to mix over a cauldron (baking soda, vinegar and dish soap), and black robes and wands to complete the wizard look. Tell me what child wouldn't love to come play dress up, wave a magic wand and have a little fun making bubbling potions? We also prepare a package I mail to the home that includes their acceptance letter to the Cloud 9 School of Magic, a ticket to ride the train, and a bag tag for their luggage. The package we mail looks like an old-time envelope and is sealed with a wax stamp. When Ashley received her package in the mail, her mom told me she started jumping up and down with excitement. She could not wait for her session at the studio.

When Ashley arrived for her session, she was ready to go. I greeted her at the door and walked her through getting her wand and wizarding robes.

Once in the studio she was totally in character. As my assistant poured the warm water over the dry ice in the cauldron and the smoke started billowing over, the look of shock and surprise on Ashley's face was priceless. As she started mixing the "dragon's blood" with the "pond water" and "wart's powder" (again, made from dish soap, vinegar and baking soda) I had her speak out a spell and wave her wand. The moment she waved her wand the ingredients began to interact and started bubbling over her test tube. She did it! She mixed a potion and created magic! This continued for half an hour, and during the entire time Ashley was in fact a wizard in her mind. The characters she loved to read about she had become. In the session, she lived out actions she had only dreamed about.

When Ashley and Lisa came to view her finished images a week later she was still excited about the session. As the images came across the screen she kept jumping around and waving an imaginary wand just like she did during her session. This was an experience she will never forget, and if she does, her mother has a beautiful artbook and wall portrait to remind her!

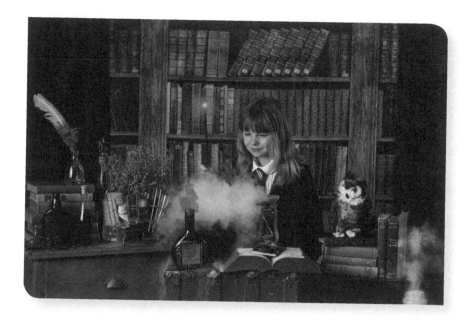

With our wizarding sessions I believe I hit on something more than just the love children have for the magical world. The parents of these children also grew up reading these books and have been waiting for 8-10 years since their child was born to be old enough to read the same books they loved! Every parent I talk to can tell me how excited they were that their child was finally the right age to read the books or watch the movies. Strangely enough, reading Harry Potter has almost become a new rite of passage for children! Parents can share a passion they have with their child and not only engage in reading together but also compare thoughts on characters and events. Now, they can also travel to a theme park to enjoy the full experience. Just like Santa is an experience and magical belief that spans across generations, I believe that Harry Potter is doing the same thing. As each new generation of kids become of age to read the books, they get to live through the same adventures their parents did.

The success of these wizarding sessions made me realize I needed to come up with other ideas just like this one to reach both boys and girls, and of various ages. Each year I sit down and plan out the following year

with themed ideas that involve dressing up and acting out a child's favorite fantasy. We have done mermaids, pirates, old-time baseball, and space days, just to name a few.

Essentially the goal of a well-designed theme session is two-fold: first, it is designed to fully engage and excite the child before, during, and after the session and second, it should trigger a sense of nostalgia and happiness for the parent to see their child enjoying this experience while also bringing them closer together as parents/ children. Beyond these, a theme session also provides a family with artwork they are proud to display.

Tips For Parents Eager For A Themed Portrait Session:

Choose a theme that is age-appropriate for your child. Sometimes the delayed gratification is harder for the parents then the child! For example, because of the glass bottles and potions, I won't photograph children under five years old on the Wizarding Set.

Choose a theme that will interest your child and engage them during the session. This can be a theme that hits on one of your child's obsessions, hobbies, or favorite characters.

Talk with your child and get excited with them prior to the session. Doing this ensures the days leading up to the session are filled with anticipation.

Pay attention to the preparation instructions you receive from the photographer. Sometimes the proper clothing can drastically affect the finished artwork.

If you don't see a theme that you are interested in on offer, try asking if you can have a custom theme designed just for your child. While this may be a larger investment, it may very well be worth it if the end results are the perfect portrait of your son or daughter!

Chapter 13:

Kids Are Kids Are Kids ...

Most of the chapters in this book are about how to best photograph or prepare to photograph the many milestones your child goes through as they grow up and why it is important to create a portrait for that age. This chapter is a bit different. While all children will hit the same developmental milestones in their lives—of course, in their own timing—all children are not the same when it comes to temperament. While a five-year-old portrait is an important one to document the transition from toddler to school age child, the personality of that five-year-old may vary and therefore the session itself is handled completely differently. The parents will head into the session with different fears, concerns and expectations depending on their child.

Across all ages of children there are several distinct personality types. Ever since I took my first personality test in high school I have been fascinated by personality characteristics and how they affect relationships, the way we interact, how we think and act and even how we photograph! I use personality typing in all areas of my business. At my studio I give potential employees the DISC profile test to see whether their personalities will align with the position I am hiring them for.

While I can't give children a test prior to their session, I have become very quick to size up a child and their personality type within the first five minutes of their arrival to my studio. By understanding where a child is coming from, it allows me to get on their level and bring out their true personality for their portrait. You can't treat all children the same, you have to treat

them the way they want to be treated. What works for a shy child would bore a wild child to tears and vice versa. Understanding what makes a child tick is what gives me the edge I need to relate to who they are. This relatability is what allows me to bring that child to life with my camera.

For the most part, the characteristics of a child's behavior in the studio originate from their temperament, attachment to parents, parenting style or a combination of all three. As a child ages they begin to develop a sense of moral obligation to obedience and following social guidelines. During a consultation with parents ahead of the session, I can get a pretty good sense of where this child is not only developmentally but also socially from the stories they tell me. Most parents don't sugar coat the truth when it comes to the attitudes of their children. In fact, I have often found the opposite— many parents make it sound much worse than it is ("Oh trust me," they'll say, "if you get a single photograph of my child looking at the camera it will be a miracle!") Well, I assure you, I have seen it all and can manage any child in the studio, but I will never deny a little help from above either!

Of course, every child is unique, and the following attitudes are by no means an attempt to stereotype children. These are, however, the most common attitudes I see walk into the studio and they are general enough to be able to address as a photographer when trying to capture the best image. These attitudes and temperaments are also not always age-specific, nor are they necessarily permanent. Still, it can be helpful to recognize these personality traits as a parent, so that you can be prepared for your photograph session and have the best session possible.

The "Shy" Kid

The Parent Fear: My child won't detach from me long enough to take a photograph.

When the child first walks in the door and hides behind their mother or has to be coaxed into the gallery area, I know this child will need to warm up.

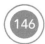

The "shy" child is typically one of my favorites to photograph because they can deliver an incredible range of expressions. When greeting a shy child, I tone down my usual approach (I am not a quiet person!) After shaking mom and dad's hands, so the child knows I am an ok kind of person, I will squat down on their level and start a conversation with them. This throws many kids for a loop. Most adults never get down on their level to talk. Can you imagine life where everyone you talk to is a few feet taller than you and you always have to look up? No wonder you hide between mom's legs if you're shy—it can be a very safe place! When I get down on their level, I can immediately see a bit of a change in the child's expression. They will look me directly in the eyes, even if they hide a bit in between glances.

I have also found that shy children are sometimes afraid they will be left behind at the studio and worried their parents are leaving. I use language right away in our conversation that assures them we are all doing this together. If there is an older sibling as well, I will talk with them and then shift back to the shy child, or if they are the older sibling, I will ask them questions about "their baby" sibling.

Most adults aren't silly when it comes to interacting with children, unless they are clowns, magicians or other entertainers. While I am definitely no clown (in fact I hate clowns and it even scared me a little bit to type the word) I do find that being a little unexpected in a calm way helps to warm up the shy child.

For example, when Jamie came to the studio, she was four years old. During the phone consultation I had with her mother she told me in no uncertain terms that Jamie had never had a professional portrait session because she couldn't pry her off her legs long enough for it to happen. They had even been to other studios only to fail at their attempts. I assured Jamie's mother not to worry, I had many tricks up my sleeve and loved shy children.

When Jamie came in, I sat down on a chair that put me at her level and started asking her questions. We began chatting about her very sparkly shoes and her toes that were painted so perfectly. During all of my basic questions she nodded, still clinging to her mother. When I asked her if her

kitty cat painted her toe nails, she gave me a little giggle and said, "No!" There it is. I got a word and I knew we would be fine.

Over the course of the next five minutes I continued asking her questions, a series of serious questions followed by completely unexpected silly ones. For example, I asked her if the curls in her hair got that way because she drank too much orange juice this morning, then I asked her if the bunny she was holding came to life when she was sleeping and played with the other animals in her room. With each question, Jamie would giggle and become a little more comfortable with me. Once we moved into the studio and I asked her if she would help me photograph her bunny named—wait for it—"Bunny," she brought the bunny away from her mother and sat on the chair with her. I looked at mom and winked, giving her the cue to be quiet and let me now direct the rest of the session. If mom opens her mouth to say something, the spell will be broken, the child will remember she is not next to her mamma and go running back.

You see, while shy children take a while to warm up to other adults, they can all usually be won over with the right dialog. I have found that most shy children begin their sessions seriously, with slight smiles and end with bigger smiles and sometimes even a few laughs and playful shots. It simply takes patience and about 15 minutes to get them there.

The "Walk Right In and Take Over" Kid

The Parent Fear: My child is too headstrong to listen to a photographer and take a nice picture.

What is the opposite of shy? The child who has swung open the front doors and come busting through the studio before their parent is even out of the car. Many of them walk right back in to the studio like they

own the place and say, "We're here!" When this happens, I must say I always giggle to myself, thinking, "Oh boy, this is going to be a fun session!" Unlike the shy child, zero warm-up will be required. If anything, all of my focus and energy goes into slowing this child down a bit so I can actually converse with mom and dad to find out their goals for the session and what they brought with them. I have even had to have my assistant go guard the lighting and gear occasionally from the "take over" child while this conversation is happening because they are all over the place!

The key with this child is getting them on your side from the beginning. They love being in charge and we need to harness that energy for good instead of allowing them to be bossy during the session. If I am not careful, this child will try and control the entire session. I love asking them for their ideas or getting their "help" with something to set up for the session. Just like all children, if you can engage them in an activity, whatever front they have put up typically comes down and their childlike self comes out. These children love to perform for the camera, the trick is getting *real* expressions and not the ones they want to give you, like the chin-up, cheesy, ear-to-ear grin.

In sessions with Take Over children I work a tad quicker, with energy to match theirs, and always stay one step ahead of their clever little minds. These sessions are usually shorter as not only do we get the images we need faster, but once these kids are done, they are *done* and all my tricks will no longer work.

For the Take Over kid, I never put my camera down until the parents have pulled out of the parking lot. Sometimes when you least expect it, like when the parents are meeting with me to look at the calendar to pick a time to come back to view their images, this child will come up with an idea that is gold! For example, I had one session where we were completely done, I mean we had photographed for close to an hour, the child had already changed into their street clothes and the car was mostly packed to leave. The boy jumped up off the chair in the gallery and said

"Ms. Jeanine I have another idea! Can I take your picture?" I stopped and giggled and almost said "No ..." but then I thought to myself, "why the heck not!" It's not like I don't have an assortment of old cameras laying around in the back, so I dug out an older camera, loaded it with a flash card, brought the child back to the studio and we had a "shoot off!" I photographed him while he photographed me. It was hilarious, the images are adorable and his mom still talks about those five minutes of the session to this day!

The "Thinks They Know It All Poser" Kid

The Parent Fear: My child will not show us a real smile, the one I see at home.

This child is usually a dancer, gymnast or pageant child and because they are photographed a lot in their activity, they think they know what is happening and what I am expecting and will begin posing before I even say a word or pick up my camera. I have found the best thing to do with these little "posers" is to let them have at it at the beginning of the session. I will let them engage, have fun and show me their best stuff. Once we do that for a little bit, I tell them we are going to change things up and if they will work with me on some of my poses I will let them take over again at the end.

What I find amusing is this personality transcends throughout all ages! There is always a segment of my clients that think they know how to pose better than I know how to pose them. This manifests at all ages, from the child who pops the hand on her hip and tilts her head, to the teenager who thinks they are posing for a selfie or the cover of Vogue magazine, to the adult who claims they only have "one good side" and no matter where I put them, change to that side. The key is to listen or watch what they are doing and then adjust. When I work with someone

with this level of confidence I embrace their self-awareness and then modify for what I know will look best for them and the portrait we are trying to create.

In the past two years I have had a lot of experience with this attitude because my sister has entered into the world of pageants with my nieces. My four-year-old niece has been trained by a professional pageant coach to pose, walk, smile and stand a certain way on stage. When she comes to my studio for portraits, she goes into her "performance" mode and does what she has been trained to do. While these poses and smiles work well for pageants, they don't work well for a portrait as they tend to look forced and not natural. I have to get her out of "pageant mode" and back into kid mode in order to see the expressions I know and love from her. Of course, I let her do her "pop toe" and other pageant poses to make her happy, but then Aunt Neanie (as she calls me) takes over and diverts her attention with a fun activity like eating giant lollipops, stacking strawberries on a strawberry stand, or dancing as a fairy.

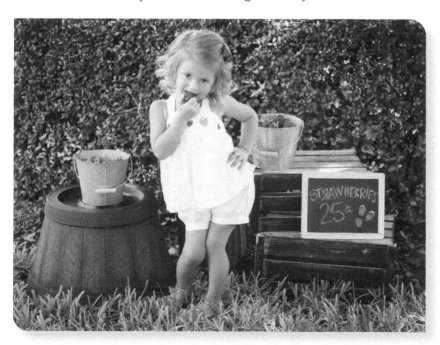

The "Parent Pleaser" Kid

The Parent Fear: My child will not meet my expectations.

Similar to a shy child, the parent pleaser is a bit easier to coax away from mom at the beginning of the session but wants their mother's approval for everything we do. Their eyes are always leaving mine and looking over at mom. While profile images and emotional shots with eye contact off-camera can be amazing, for the type of photography people come

to me for, I do need at least a few images with direct eye contact to the camera. Having mom stand behind me can help, but even then you can notice if the eyes are slightly off.

I did a little research on this personality to understand what causes a child to constantly look for parent approval and see if I could find any nuggets of knowledge to help give me an edge in working with them. I found that for the most part the parent pleasing child can come at me from two different angles. One is that the child at home has strict rules and the child wants to please their parent and seek approval to be assured their parent is happy with their behavior. The other comes from inside and the child wanting to be a "good boy or good girl" and seeking praise from their parent for a job well done.

I approach children like this in a similar way to how I work with a shy child. I keep mom around just long enough for them to know she isn't leaving the building, they are safe, we are going to have some fun and that no matter what, mom thinks that I am awesome and they should trust me. If I'm able to get the child to look directly at me with mom in the shooting area, I will tell her just to hang out near me. If it becomes a problem with them always looking at mom, I will usually get mom to leave for a few minutes by giving her a very important task, like going to grab a battery light for me. It doesn't matter what errand I am sending them on, the key is it is a short errand, the child knows they have to come back to me, and for those five or so minutes that child's eyes are mine!

The key I have found with these children is to constantly reassure them that what they are doing is amazing. I use words and phrases like, "Oh, Jenny that is the perfect expression" and "Yes! Your feet are posed perfectly, look at you, being so good!" or "I am so proud of you! You are doing everything I am asking and this is going so well!" Words of affirmation and praise will get you everywhere with a child looking for approval.

153

I find the parent pleasing child to generally be very sweet and loving. By the end of a session these children are usually coming up and giving me hugs, telling me what fun they had before heading back over to hold mom's hand.

The "Stubborn" Kid

The Parent Fear: My child cannot be tricked or coaxed into a decent photograph.

Ahh, the stubborn, I-don't-care-what-you-say-I-am-standing-here-with-my -arms-crossed-and-you-can't-stop-me, child. This is the child that strikes fear into the hearts of all photographers.

For the most part, I don't see this type of child in the younger ages. Most children under the age of 10 haven't yet reached a sense of self-awareness enough to know they can act this way. Honestly, there is nothing I can really do about it anyway. Until this awareness of their control takes place, the stubborn child is shy and more reserved. That I can work with! Typically, a stubborn child will react to humor. Luckily, I can be as silly as they come!

This past Christmas season one of my longtime clients came to the studio with her 10-year-old son, Zach. I have photographed this boy since he was two years old. When he was younger, he was the Wild Child. Often times I would joke with his mom that I would schedule them as the last session of the day just in case he should destroy the set! While a joke, it was the God's honest truth! One year we had a snow scene and before I could even say hello, he ran onto the set, slid into the snow and knocked over four snowmen. Now that he is 10, he isn't running around the studio like a crazy kid, but he did just stand there and stare at me like I had four heads. At first, I tried to reason with him, and when that didn't go so

154

well I enlisted my assistant to pull out her phone and start reading silly one-liner jokes. While he gave me a little giggle, it wasn't long enough to capture.

Then Zach's mom and I started joking about his girlfriend. Well now, that struck a chord! The first expression he gave me was one of disbelief. Girls? I'm talking to him about girls? Then his mom whispered to me that he had a silly dance. I put my camera down for a minute and told Zach I had a happy dance I did whenever the Gators scored a touchdown. Then I proceeded to dance and act like a fool. Zach looked at me and started to laugh (I mean, how could you not I looked like a fool!) Then I asked him if he had a silly dance that he did and that's when I picked my camera back up. At first, he didn't want to dance, but then his mom encouraged him gently. Zach proceeded into his silly dance, laughing the entire time and of course I snagged the shot!

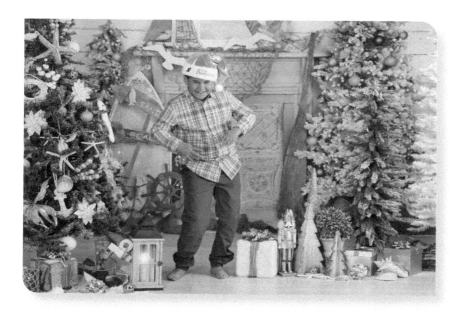

On the flip side, I had another child, McCaid, who I have photographed since he was a baby, come in this year with his sister. I have seen all sides of this child, and now he is 10 years old. His sister was a dream the entire

session, she smiled, posed was happy and really got into the theme of the set, as you would expect most 13-year-olds to do. McCaid on the other hand refused to smile. He literally crossed his arms and said, "I am not smiling, I hate my teeth, and you can't make me." Although I never, *ever* ask a child to smile, at one point I actually found myself almost uttering the words, "Please, please just smile." I knew how cute McCaid was and he was dressed perfectly for the setting. I am also all about bribes in a photography session and use them appropriately. I armed his mom with the possibility she may need to bribe him and she was all for it. She yelled out, "McCaid! I'll pay you $20 if you smile for Ms. Jeanine." Snap! That worked like a charm and he lit up like a Christmas tree! I got at least three perfect smiles, all I needed for this session. After that McCaid went back to his grumpy look but we were able to then get him to "act" for some silly poses and expressions that were fitting of the Christmas Story scene being photographed.

The key with stubborn children is finding what out makes them tick and why they are in this mood. Why are they refusing to cooperate? Are they self-conscious about their bodies? Are they mad at their parents? If I can quickly diagnose the why, I can usually combat the situation and turn the session into a success.

The "Wild Child" Kid

The Parent Fear: My child will destroy the studio or location of the session before it even begins and we will owe a lot of money for broken equipment.

Unlike the Take Over Kid that busts through the doors of the studio ready to take charge, the Wild Child Kid is all over the place. They usually walk in calmly with their parents and after a few minutes of introductions begin to get a tad on the crazier side. It is important for a Wild Child to understand that in the studio I am in control of the photography, but I make sure to give them control over something specific. Some of these children come from homes that have less strict rules and emotionally bond with their parents more as friends as opposed to authoritative figures. They may also just be children that are easily distracted and do not have the fears or inhibitions that keep other children under the studio spell for 15-30 minutes. My goal is to get this kid on my side quickly, reign in their lack of fear and harness it for good so we can get incredible photographs. If a parent tells me during their consultation that the child tends to be a bit wild, then I will structure a session accordingly from the beginning and perhaps suggest a theme that requires the child to think and do things in an order.

For example, even the wildest of children behave and become very calm when we photograph them with the baby ducks every spring. They pay attention as I walk them through the steps of how we care for the baby

ducks and what we will be doing during the session. They are so focused on the animals that they almost forget to be crazy! While they may be a bit jittery and moving around a lot when they first walk onto the set, they calm down as soon as I tell them, somewhat sternly, that they have to be still so as not to scare or hurt the baby ducks. My assistant will then show the child how to sit and place the bucket holding the ducks in their lap. When the ducks pop up and start peeping these children give the most genuinely happy and excited expressions! The fact that they don't have any fears always lends us to them being able to handle the ducks and hold them close to their face, balance on their shoulders and group them together on their laps.

The key with these children is to make sure they know the studio does have rules that must be followed. I use my "teacher" voice to get the expressions I want in the first 15 minutes, and then give them a bit of power and authority to do something of importance during the session.

Each Child Is Unique

While the characteristics above describe the different children I see and work with in the studio you will notice it covers a variety of ages. The underlying reasons why a child acts the above way can vary depending on their age. Self-esteem development begins around six to seven years old and can play a role in how a child interacts with adults outside their family circle. Young dancers and performers have already developed a sense of self around these situations, which is why they already have a high self-esteem in front of the camera.

There are also children with special needs. This can range from children who are on the autistic spectrum to children with a physical disability, and also children who have cancer and other life-threatening diseases. Whenever a child with special needs is being photographed the need

for a consultation with the parents is a must. Whatever the disability or need is, this child deserves to have the perfect portrait of who they are. In order to capture their true essence, I need to be able to see into their world, I need to be able to see them through the eyes of their parents. My advice to parents of special needs children is to research for the best photographer in your area that has been trained to photograph your child.

I know that as a parent, you are often worried that your child is "not normal." I also have parents frequently apologize to me for how their child is behaving. I included this chapter because I want you to understand that when you bring your child to a photographer "not normal" is perfectly acceptable, in fact it is embraced! The way your child acts is what helps to create their story in a photograph. Stop apologizing, stop worrying and start enjoying the moments. Use this chapter as a way to identify your child's personality type and give your photographer a heads-up prior to their session (or, let this affect how you approach your child when you want to take pictures yourself). It will help them prepare properly and will give you a peace of mind knowing that you will love the end results.

Note: in the tips below, you will see that I mostly talk about training you, the parents, on how to act prior to a session! Ironic, right? I cannot emphasize enough how critical these tips are. Positive and exciting attitudes on the part of the parents goes a long way with the child. This is not only true for young children but teenagers as well! When teenage daughters and mothers are fighting about clothing, hair, makeup, or boys coming in to the session, the teenager will not be in a happy mood and will have a hard time getting in to the posing and expressions. Save the arguing for later, suck it up and be agreeable for the sake of the investment you are making in their portrait.

Overall Tips When Considering Your Child's Temperament Prior To A Portrait Session:

When talking to your children about their upcoming session always use positive emotions and simple descriptive words. I find that many parents sabotage a portrait session before it happens by the way they talk about the session with their child. Bribing them prior to arrival or telling them "they better behave" implies that they shouldn't enjoy the time they spend being photographed. This language needs to change. Children are smart little creatures, and they will know you expect them to not have fun and therefore they will not be excited. Help your photographer out! Speak positively and be excited about the portrait session so that your child will be too!

The photographer is the director of the portrait session. As with a movie, there can be only one director. If your photographer has to fight you throughout the entire session for the attention of the child, the results will not be favorable. Allow the photographer to interact with your child and fix the details and expressions. Never, ever, ever, under any circumstances yell out in the middle of a session, "Smile!" or any other instructions. Your child must stay connected to the person creating the art. Causing your child to feel like they have to also listen and get your approval will often lead to tears, fake smiles and general grumpiness.

Bribing may certainly be needed in a session, however the bribes should not come from you. There is a specific point in a session when your photographer may decide this is necessary and only then will they suggest it. If you jump the gun and start saying things like, "Cindy, if you smile for the photographer, I'll give you candy," then you have just set the tone for the rest of the session. This is what you have hired a professional photographer to do. Sit back, relax and trust they know what they are doing.

Unless your child is being destructive, causing physical harm or being disrespectful, do not discipline your child verbally in the session. In all my years of photography I can tell you with 100% certainty that a parent yelling at a child has never yielded a smile or happy expression. Kids may act out at times during the session and your photographer can most likely handle this. Give them a chance. Now, if your child jumps off their chair, runs over to the lighting equipment and starts to knock it over, kick at it or throw things, then by all means jump on it, but please do not yell at a child who is merely being a child and not giving the expression you want in that moment.

Conclusion

L ife with children can be crazy, exhausting, insane and frankly quite draining. As parents we often get into survival mode and are stuck going through the motions of each day's routine from waking up and getting to school, to coming home and doing dinner, bath and bed-time. We can be so busy and tired that we oftentimes dream of the days when life isn't so crazy.

Here is the thing, though: these days go by so fast. Even in the midst of life you can look back on a single year and be like "damn, where did the time go?" Soon enough the baby who doesn't sleep through the night is in kindergarten, and the child who snuggles up on the couch to watch morning cartoons is in high school. Busy schedules of baseball practice, dance competitions, and homework will be over soon enough. When your children grow up you won't remember the exhaustion in a negative way, you won't remember the endless amounts of laundry with a grumpy face, you will remember the laughter and the kisses and the snuggles and the way your children needed and loved you. Treasure every day you have with your family and children. Stare at your toddler and memorize their face, the sound of their laughter and the words they say. You will look back upon the photographs and portraits you kept and remember each of the moments that were captured with a fondness and longing of the days gone by.

Above all, I implore you to make sure you have your photographs and portraits printed in a way that you will have them 18, 30, and 50 years from now to look back on. Because as much as we promise ourselves we won't forget our daughter's fifth birthday party, or our son's first soccer game, we will. Our brains are funny that way. But as soon as you pull that photograph out of a box, look through an album or walk by a frame on your wall, those memories will come flooding back into your mind and you will smile all over again.

As we approach the ending of this book, I want to leave you with a few action steps you can take to maximize and leverage all of the information I've shared with you in these pages. After all, what good would it be to go through the planning and execution of 18 years of photography and then not have anything to show for it?

Here are my tips for getting the most out of capturing your children and family in portraits:

1. **Make a timeline.** Get out a piece of paper and jot down a timeline starting with today and continuing until your child is 18. Think back to the chapters of this book and sketch out a Photography Timeline of what you feel are the must-have moments. In Appendix A, I have created a sample timeline for you starting at birth. Keep this timeline handy and it will guide you to ensure you get to the 18th birthday with all the important memories captured forever.

2. **Display and store your portraits.** Here are a few ways you might want to think about displaying and/or storing your portraits:

 • The **walls of your home** are calling out to have your children and family portraits hanging on them. Remember, children that grow up surrounded by photographs of themselves and their family are more well-adjusted and self- confident because they see these images daily reminding them they matter and they belong.

 • Assembling **albums or memory boxes** is a wonderful way to keep many images over several years in an organized manner.

- **Table-top frames** that you can rotate through images allow you to easily store and change out what is displayed during different seasons. For example, one 5 x 7 frame can store many images inside and you can rotate new photos to the front depending on the holiday or season.

- **Digital archival storage** should definitely be looked into for ensuring your portraits will never be lost. I encourage you, however, to not use this as the only method of saving your images. Images that are not printed but only brought up on phones or computers are not enjoyed and don't have the same effects on children and family.

3. **Make a gift plan!** When planning each of your photography sessions, be sure to add into your budget giving prints of photos as gifts to grandparents and important friends and family. Life is something we share with those closest to us. My children love looking at the photographs I have up of their cousins, other family, and even my best friends. Our photos serve as a reminder that although we don't see each other often, we are all still family and the love is there.

Whether you set out to become your own family historian, or you establish a relationship with a local photographer, it is my hope that you invest in the preservation of your family memories. These are the stories of your life, your children's lives, and the stories your children will tell their children. If you don't preserve your legacy, who will? It is my sincere hope that you find all of the tips I've shared useful, and that you come away feeling inspired to capture the magic of childhood by telling the unique stories of your children through photography.

Join Me Online

I would love to invite you to join my Private Facebook Group dedicated to parents who appreciate the importance of capturing their children's story in portraits. The group is called "Loving Life on Cloud 9". Join us in conversations surrounding photography ideas, fantastic outfit finds online, photo crafts, camera tips and much more. I hope you'll come join our little community!

https://www.facebook.com/groups/lovinglifeoncloud9/

About the Author

Jeanine McLeod is the owner of Cloud 9 Studios in Tampa, Florida. She has won national awards for her children's portraits and has been published in magazines around the world. Jeanine has a love of children and story telling which is evident in her unique style of portraiture. She juggles being an entrepreneur, photographer, and author along with the hectic schedule of having two kids in sports, music and after-school activities!

Photo by Andi Diamond

167

Timeline of Must-Have Milestone Portraits

Time line of "Must - Have" Milestone Portraits

Newborn and/or 6 Month — Baby's first portraits! If you can't hit all the first year milestones, these two are the must haves.

1st Birthday — A child's first birthday is worth celebrating with a portrait. Let them show off standing and/or walking. While they will always be your baby, they are now officially a toddler!

3 Years Old — This stage captures the creative and active play of a toddler. They still have their baby face features as they continue to grow taller.

5 Years Old — The cutest and most endearing stage of a child. The end of their toddler years and beginning of school age. They have their own interests and their faces and bodies have matured into children.

10 Years Old — The double digit birthday! Soon the child will be entering their teen years. This portrait will capture their emerging independence and personal likes and fashion. It could also be their last pre-puberty portrait.

13-14 Years Old — The early teenage years. Their childhood is behind them and they are becoming young adults. Full of independence and emotions these portraits begin to show who they will be as young adults.

18 Years Old — The high school senior portrait. This portrait signifies the official cross over from child to adult. The session should mix a sense of formal tradition as well as personality and interests.

Appendix B:

Twelve Years of One Family in Portraits

In 2006 I met Melissa and Paul Olsheski. Photographing their maternity portraits and soon thereafter their newborn session truly kicked off my journey with photography. Every year since, they have come to the studio for an annual portrait. The Olsheskis have become much more then clients, they have become family.

I could think of no better way to show you how quickly time flies as a family grows and changes than with 13 years of Olsheski portraits! It seems like just yesterday we started this journey together.

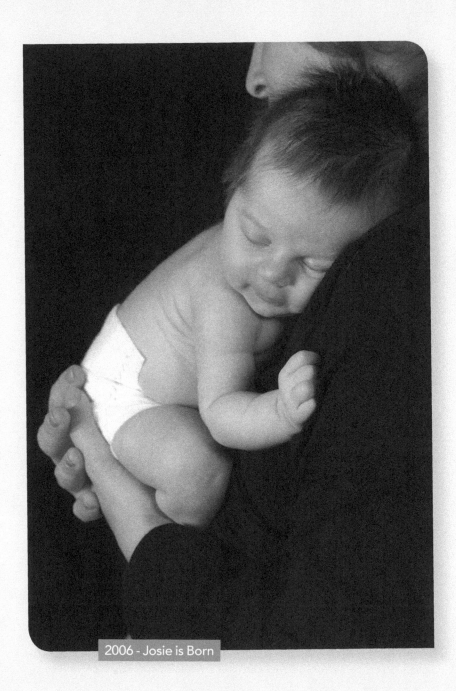

2006 - Josie is Born

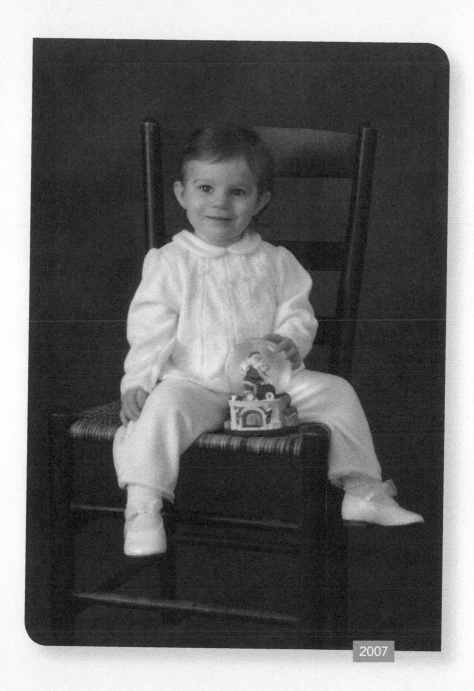

2007

2008

2009 – Welcome Baby Logan

2010

2011

2012

2013

2014

2015

2016

2017

2018

CPSIA information can be obtained
at www.ICGtesting.com
Printed in the USA
LVHW071507110619
620860LV00025B/307/P